Tom Wolfe Carves
WOOD SPIRITS
AND WALKING STICKS

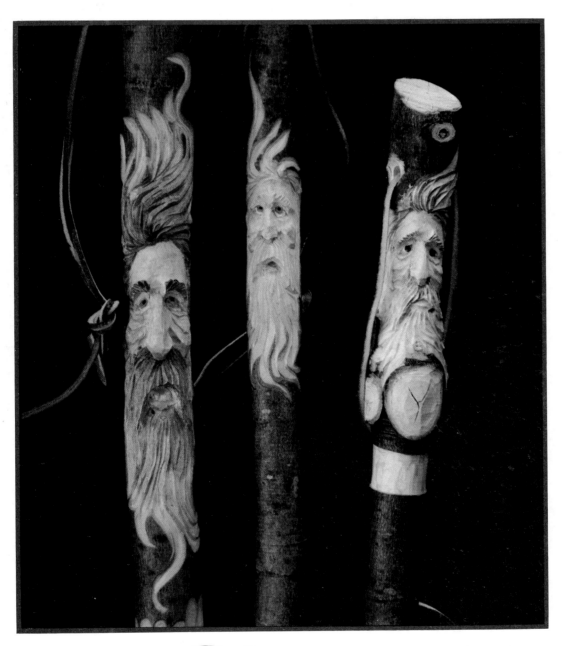

Schiffer Publishing Ltd

1469 Morstein Road, West Chester, Pennsylvania 19380

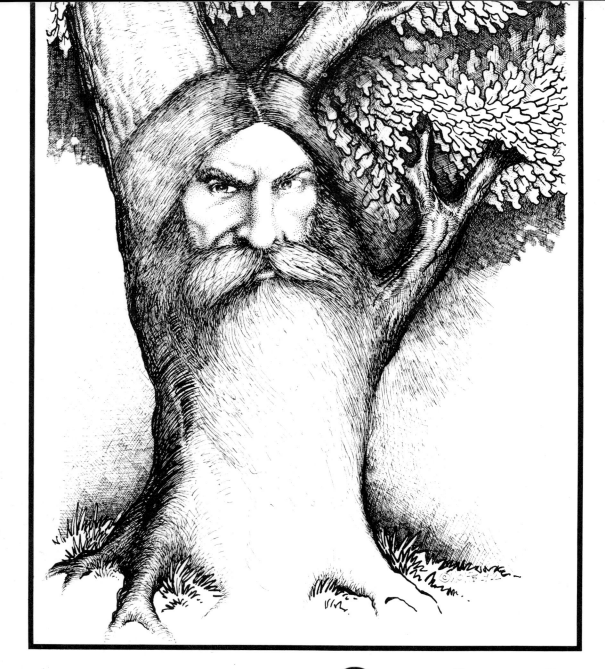

Contents

Introduction . 3
Carving the Wood Spirit 5
The Walking Stick . 39
Gallery of Wood Spirits and Walking Sticks . . . 55

Printed in the United States of America.
ISBN: 0-88740-441-3

We are interested in hearing from authors with book ideas on related topics.

Published by Schiffer Publishing, Ltd.
1469 Morstein Road
West Chester, Pennsylvania 19380
Please write for a free catalog.
This book may be purchased from the publisher.
Please include $2.95 postage.
Try your bookstore first.

Introduction

The Legend of the Wood Spirit

It goes by several names. Wood Spirit. Wild Man. Savage Man. Woodwose. What ever you call it, the next time you are strolling through the woods, keep an eye out for one of these elusive creatures.

Most often glimpsed as a green man with leaves for his beard and hair, the Wood Spirit is said to be Lord of the Forest and Natural Things. Seeing one is said to be quite a lucky thing, and European villagers used to go out on regular hunts, hoping to find a Wood Spirit to foretell the future of their village.

They are extremely strong. Wood Spirits can tear an opponent limb from limb and can tame any wild animal, including ferocious dragons and skittish unicorns. At the same time they are gentle with maidens, children, and men of good heart.

It is said that the forest will stand for as long as the Wood Spirit remains to keep order. And if you are lucky enough to see one, health, happiness and good fortune will be yours. But that doesn't happen often. Wood Spirits would rather see than be seen. Most sightings are by children or by the pure in heart.

Tom Wolfe must be one of the latter. There are many that he has seen and carved. Sometimes Tom sees the nose of one poking through the bark of a likely log, and coaxes out the features with his nimble knife blade. Sometimes he sees the flow of hair in the grain a gnarled root.

For other "pure-in-heart" carvers, and those who are just child-like, Tom leads the reader in a Wood Spirit hunt. The first stop is a walking stick, out of which emerges a wise old elf. With step by step instructions, it becomes clear that nearly every stick has some spirit living in it. And Tom will help the carver bring it out.

The larger project is a Wood Spirit that emerges from a cedar root. In a process that is as much sculpture as woodcarving, Tom leads the reader through the techniques for their own work. While it is impossible to create a pattern for this kind of work, Tom gives many examples for the carver to use as a guide. The rest is a matter of your creativity, and allowing the Wood Spirit to reveal itself to you.

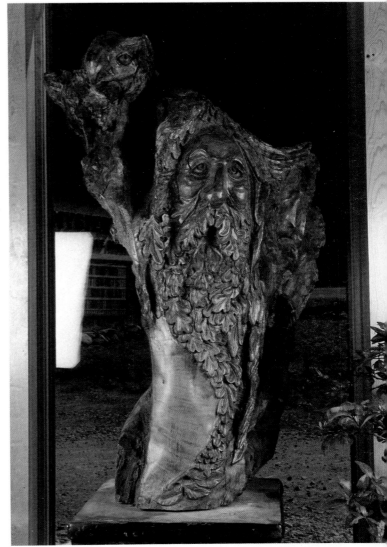

The wood can be almost any kind. Usually its the best kind of wood you can get...because it's free. It is found in the wood pile, river bank, the roadside. You discover it on a walk through the woods or on your way to work. And you can get it almost anywhere without fear that someone will call you to task.

When you take it home give it a place of honor. Give the Spirit a name and include him in the audience when you tell jokes (Wood Spirits have a delightful sense of humor). If you do these things, your Wood Spirit will bring his gentle wisdom, humor, and luck into your home. Enjoy!

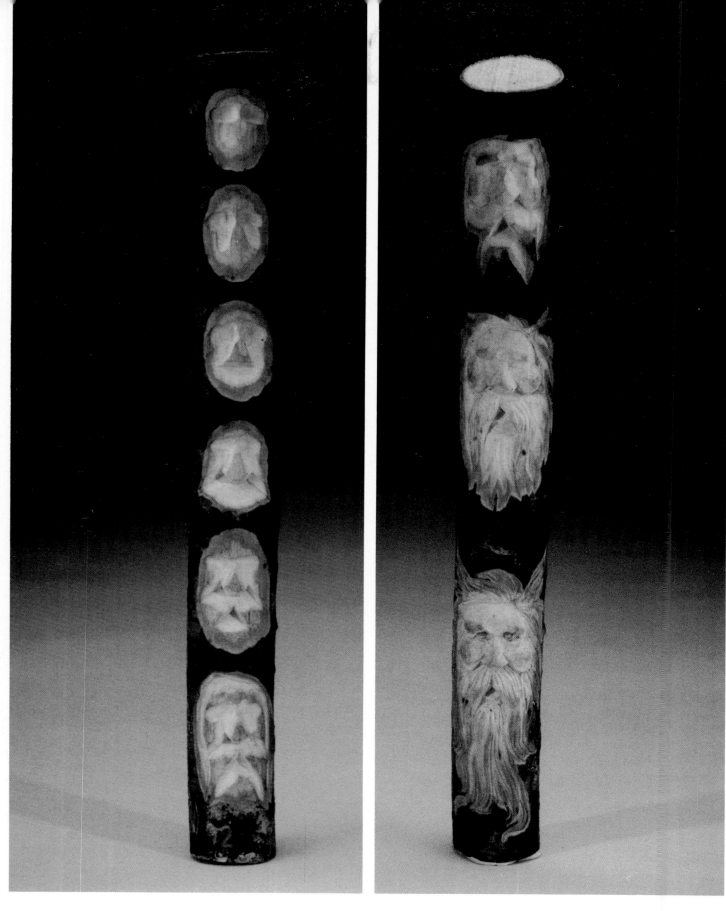

This carver's stick gives you the basic idea of how a Wood Spirit emerges from the wood. There are nine basic steps.

Carving the Wood Spirit

The brow and cheeks are carved next, along with giving the nose some further character.

After cleaning the surface of bark material, the eye sockets are shaped. Then the sides of the nose are gouged out, and the upper lip begins to take shape.

Next the line of cheeks and the upper edge of the moustache is cut, followed by the lower lip and the beginning of the beard line.

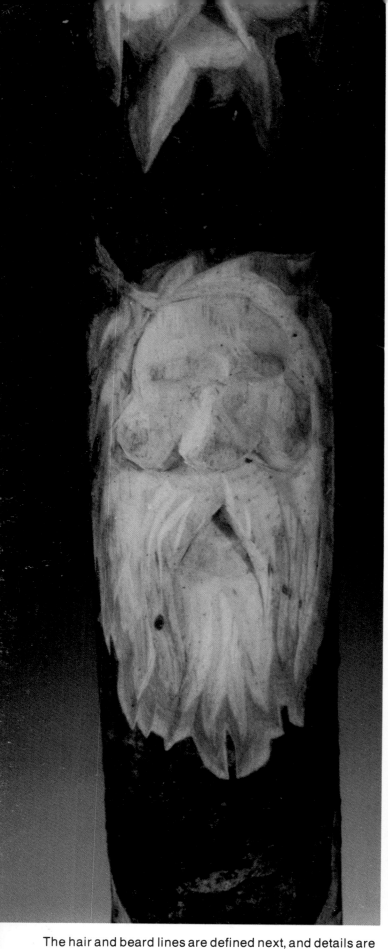

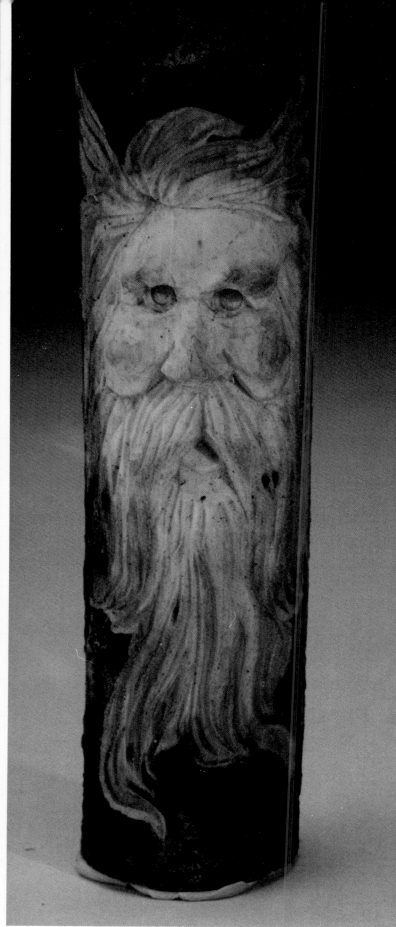

The hair and beard lines are defined next, and details are added.

Final details and character lines bring the Wood Spirit to life.

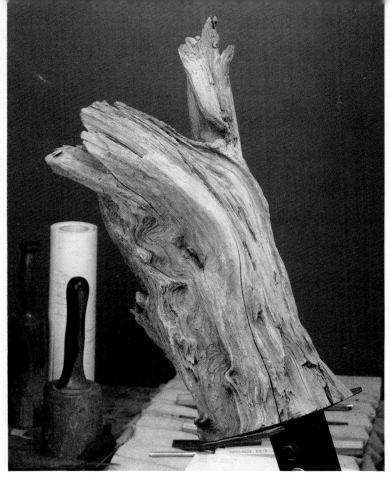

I found this piece of red cedar drift wood washed up along the shore of an old mountain creek. The current is rough and the rocks are hard, so only the nice hard wood survives. This is probably heart wood from the root.

Always clean the wood as well as possible to remove sand and small rocks. A brass or wire brush would have been much better, but a broom will do in a pinch.

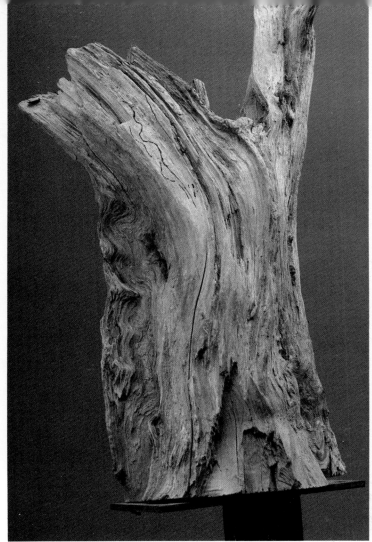

Study the wood. This grain at the upper left flows nicely and will make great hair lines. I have made some preliminary marks in pen.

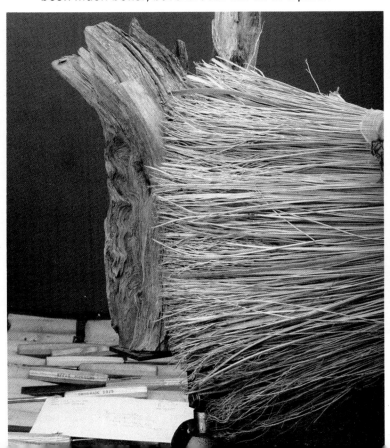

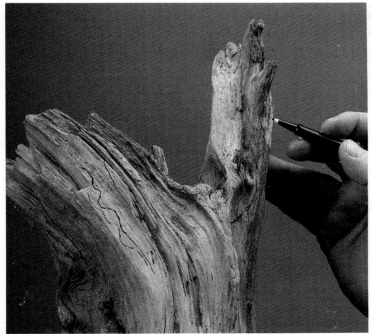

This grain is also good for hair.

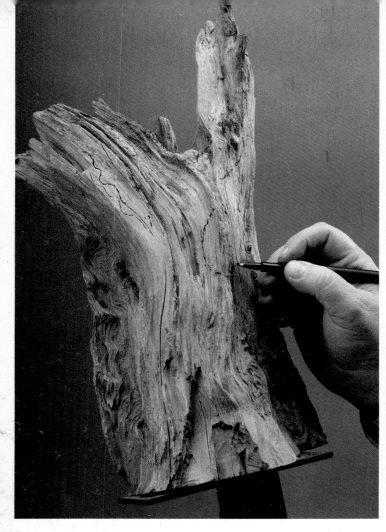

The ridge is nice hard crotch wood and will make a natural place for the nose.

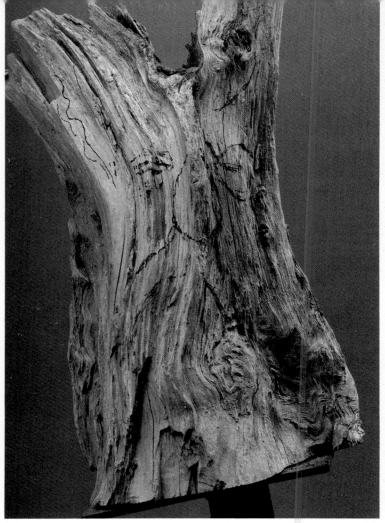

The grain at the bottom is crazy, but if you follow the lines, it will make a nice beard. You can see the Wood Spirit emerging from the wood.

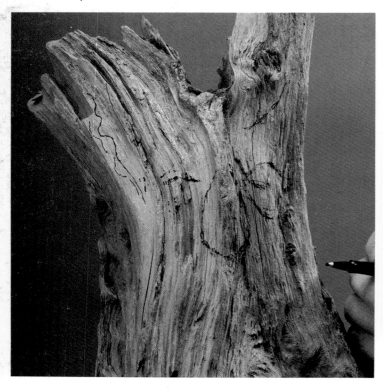

The eyes

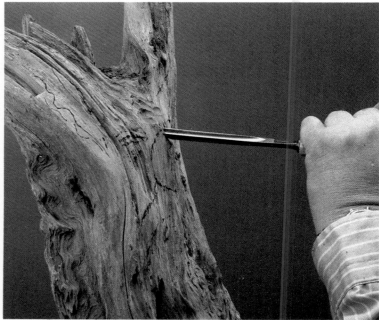

Remove soft surface wood and any soft or rotting areas underneath. For the carving to work you must get to a hard surface. Use a half round chisel and a mallet, working around the area you have marked as the nose.

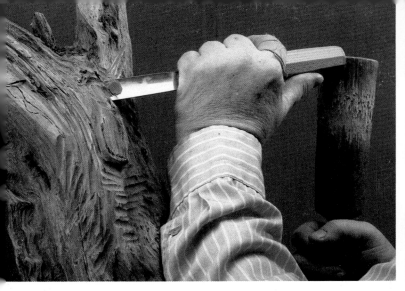

After you have cleaned the face area of the old wood, go over it with a flatter chisel to smooth the ridges left by the half round. In the process you will do a little shaping.

Skim the nose.

This is the way to hold the mallet. If you hold it too tightly you will quickly get fatigued. By letting it pivot on your fingers the energy you expend is minimal, while still giving you the power and control you need.

Skim the nose. By waiting until now, you know it is there, and won't cut it off by mistake.

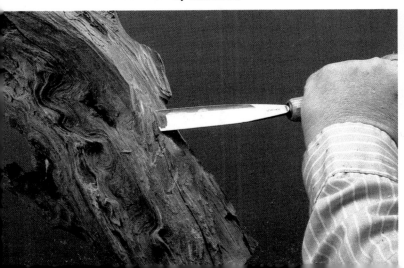

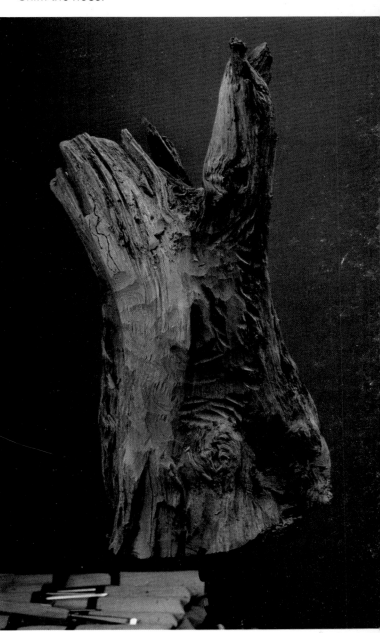

The facial area is cleared for carving.

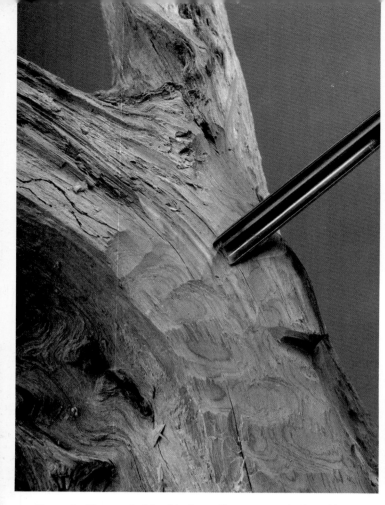

Use a half round chisel to form the eye socket and brow. As you do this, leave edge of chisel above the line of the wood. If it is lower it is likely to chew things up. This means smaller bites, but better taste.

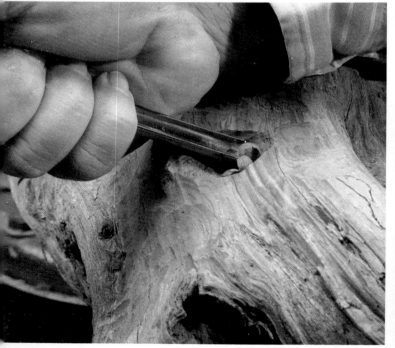

Sometimes it is just as easy to create the eye with the chisel without the mallet, coming from the outside with an arching motion.

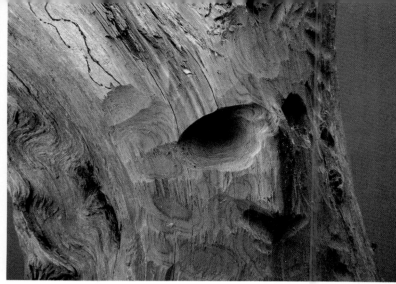

The eye sockets.

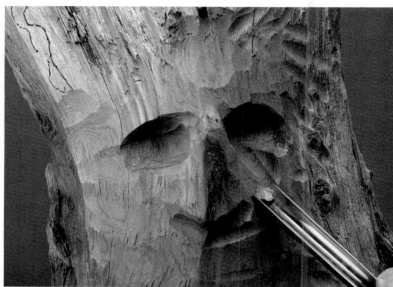

Come up on each side of the nose with a large half round chisel and mallet, creating the outline of the nose. Move into the cheek.

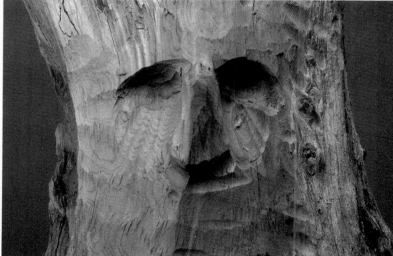

Progress. Notice how this last step has softened the lower edge of the eye socket.

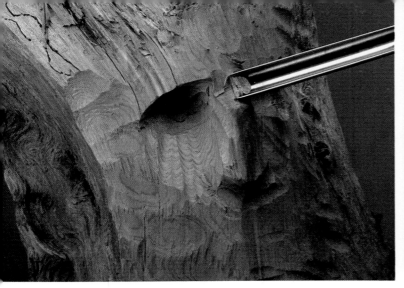

Come across the bridge of the nose with a half-round chisel and mallet.

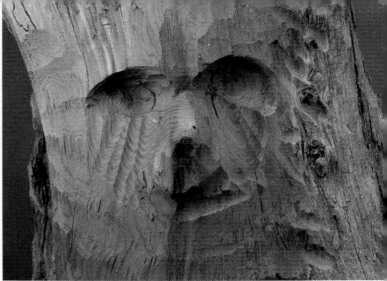

The face so far. Already you can see character and attitude developing, although you can still change it at this point.

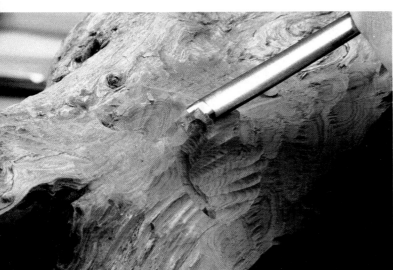

Bring it down quite a bit. Then with a flatter chisel (cup toward the work) round off the front surface of the nose.

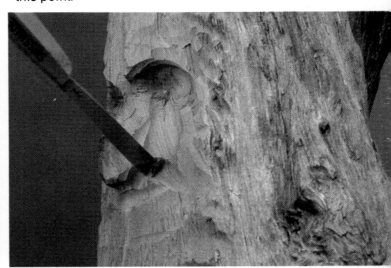

Before making the cheek/moustache line from the corner of the mouth to the corner of the nose, use a skewer chisel to create a stop behind the nostril. The cedar is tending to chip and this will protect the nose.

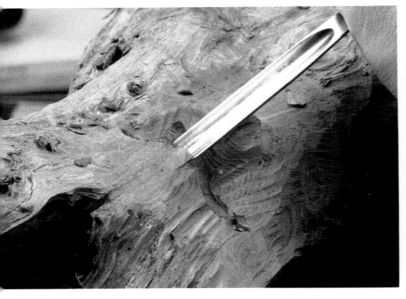

Use a half round chisel to separate the eyebrows.

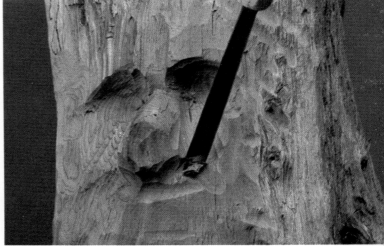

Make a second safety along the cheek line, meeting the first safety at the nose.

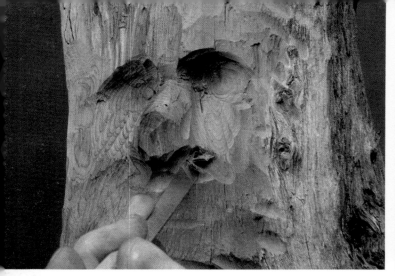

Make a third cut along the line of the moustache, and cut back into the corner created by the first two.

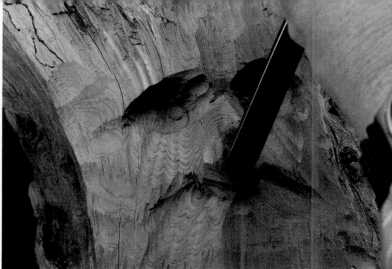

With a flat gouge (cup against the work), round the end and bottom of the nose. The goal is to begin defining the shape of the nose and getting it symmetrical.

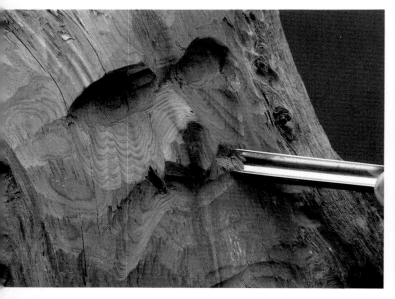

Now using the half round chisel and a mallet, make the cheek/moustache line.

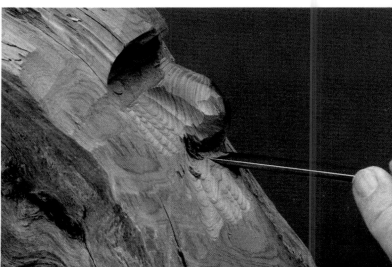

Then with the cup up, come back to the nose from the lip.

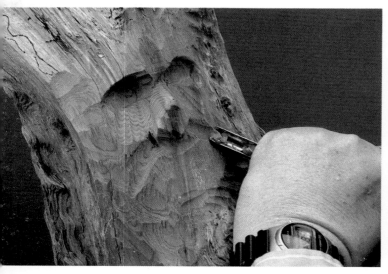

After you get beneath the surface wood, the cedar gets oily and cuts fairly easily without the mallet. We abandon the mallet to finish the cheek/moustache line.

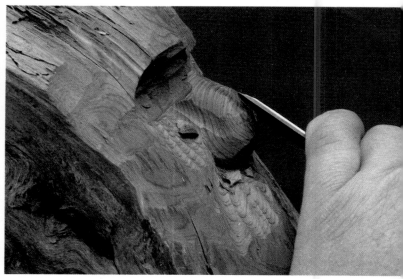

With the cup down continue round the nose up to the bridge. We want to form a nice rounded blank from which we will form a nose with character!

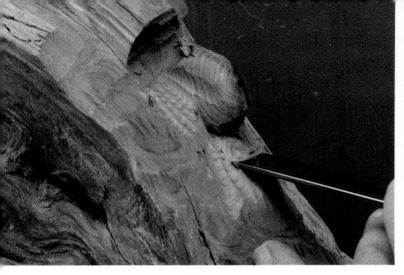

Return to the top lip and straighten it out with the flat gouge.

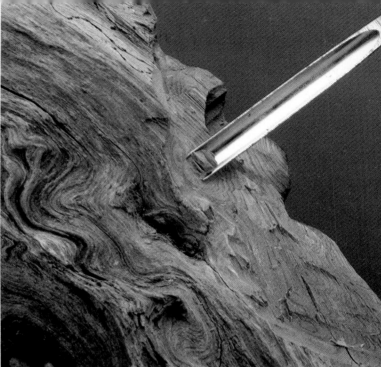

Along the side of the piece we shape the temple area. One the challenges of this kind of carving is dealing with the natural imperfections of the wood. You either have to get rid of them or incorporate them in the design. It's a real opportunity for creativity!

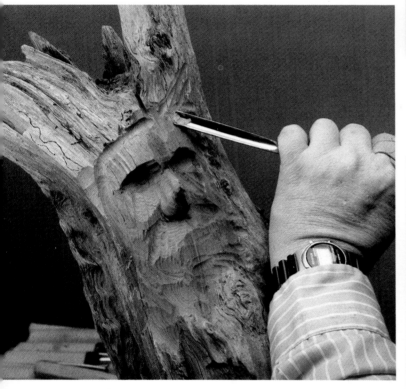

Before we go further we need to define the overall size of the face. To do this we will create a silhouette with the gouge and mallet.

As you go you can rough out the forehead and brow using a little flatter gouge. Leave plenty of wood for the eyebrows.

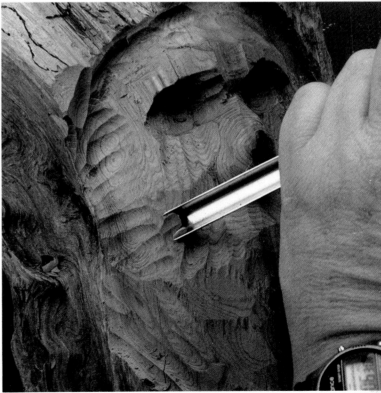

This side has less wood than the other, so I'll define the cheek line here, knowing that I have enough material on the other side to match it.

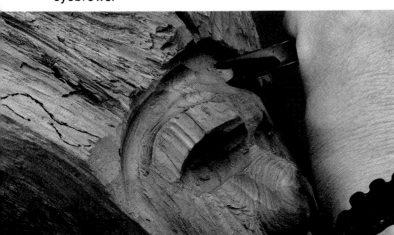

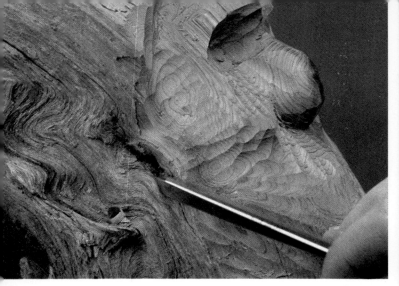

This hole is deep, and if round the face over to it, it will look odd.

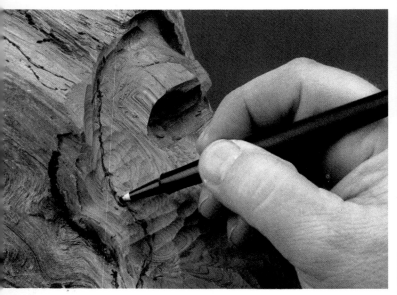

Instead I think I'll create a tuft of hair that will both camouflage and incorporate the imperfection.

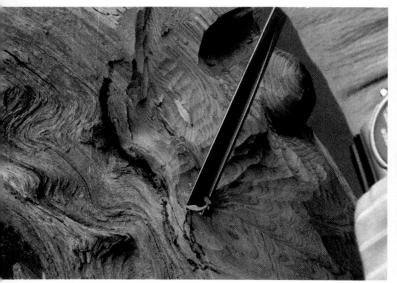

Follow the line of the hair with a v-tool.

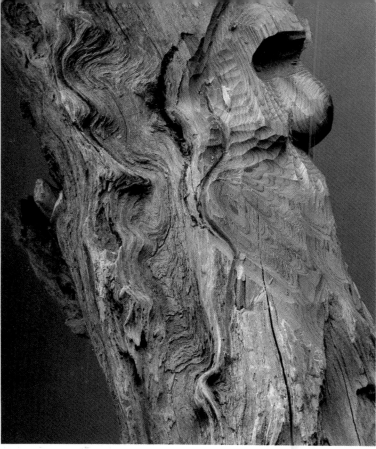

As it happens the line of the hair runs right to another imperfection in the wood that creates a natural curl. Staying aware of things like this will make a good carving better.

Find the center of the mouth in relation to the nose, and draw the moustache.

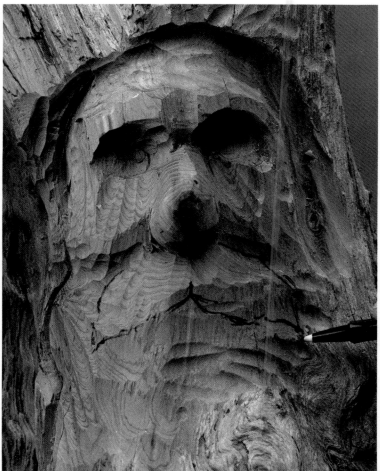

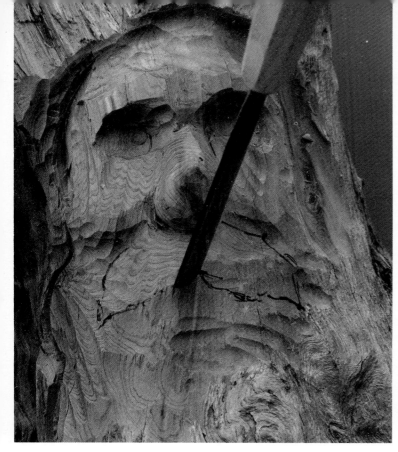

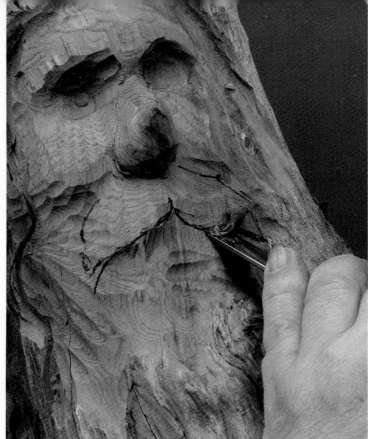

Cut a stop along the bottom of the moustache using a flat sweep chisel. The cup may go up or down depending on the shape of the line.

Here I've turned the chisel over to follow the turn in the line.

Come back to the stop using the same chisel pushed by hand.

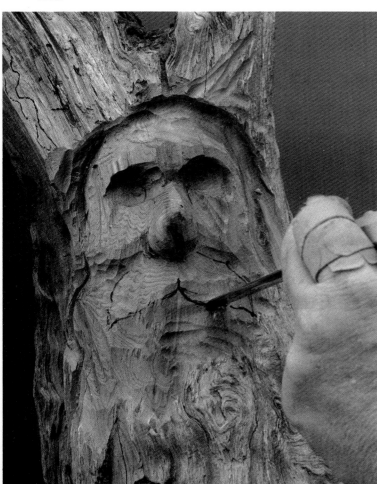

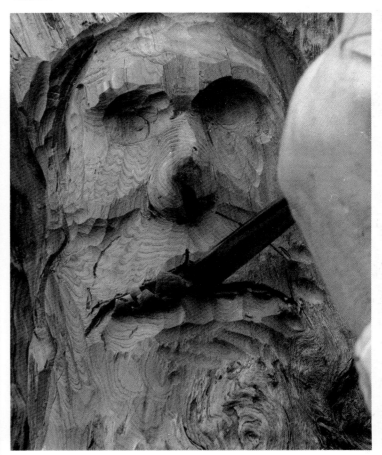

Redo the stop, taking it deeper.

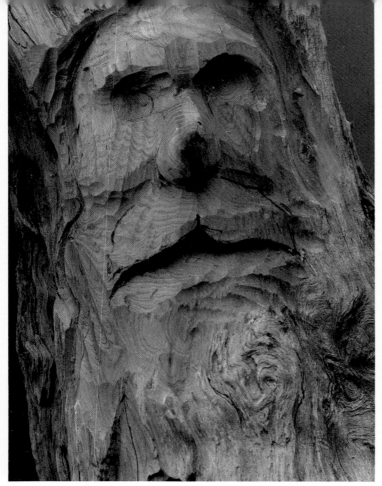

The bottom of the moustache defined.

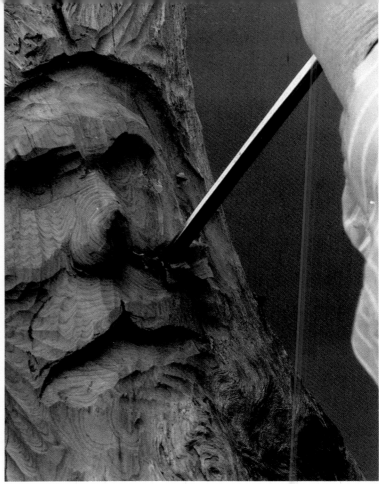

and into the line of the moustache. This creates a stop and shapes the cheek at the same time.

Come back to the stop from the moustache with the cup side of the chisel up.

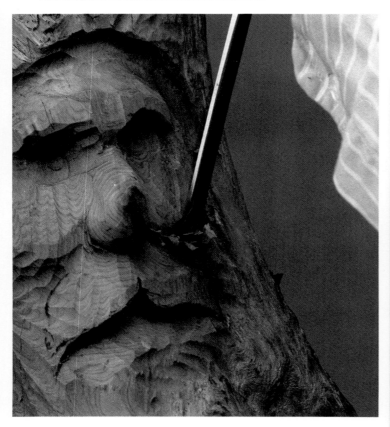

With the cup of the flatter gouge against the cheek, shape the cheek by cutting down the cheek...

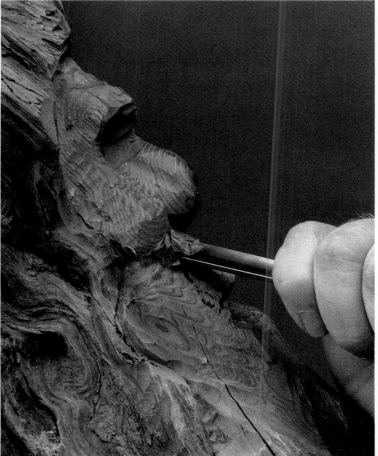

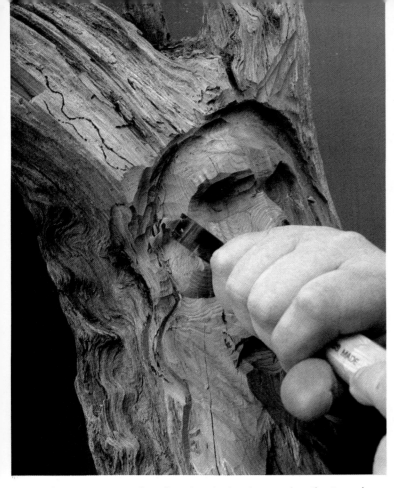

Continue rounding the cheeks by deepening the temples.

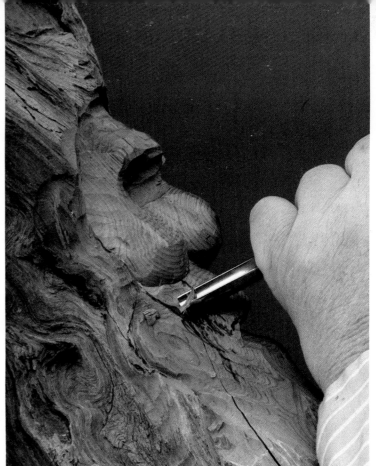

I remove the wood with a large, hand-pushed half-round chisel going across the grain.

I need to remove some of this area beneath the cheek in order to define the beard.

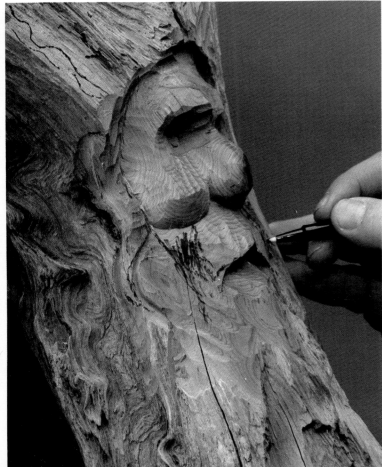

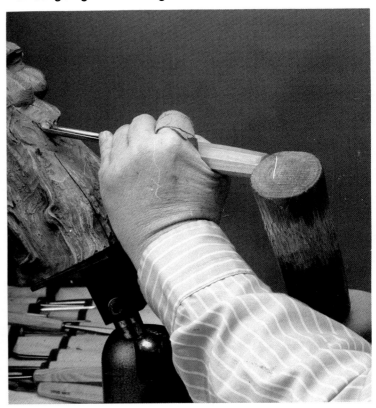

I switched to the mallet to get a smooth line, plus the control to keep the chisel from going into the cheek.

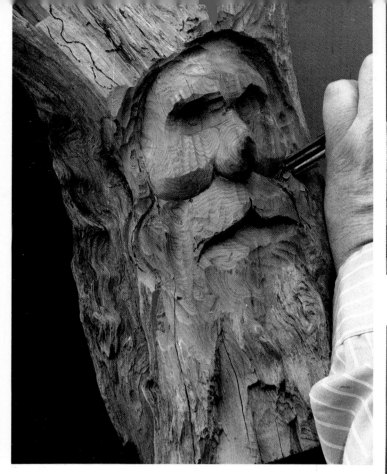

With one cheek done, I move to the other.

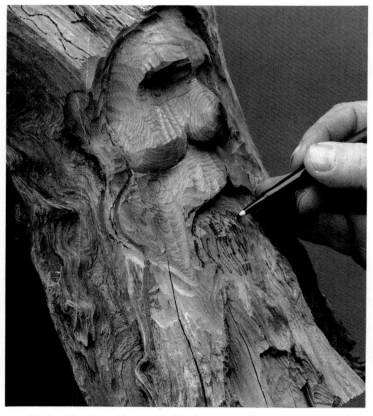

Under the mouth, one side is protruding more than the other and needs to be removed. I mark the line of the moustache and then darken the area to be removed.

The easiest angle for approaching this area is with the head reclined. Use a gouge and the mallet.

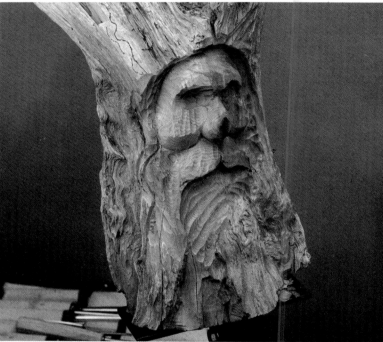

The extra wood removed enough to even up the two sides.

Now continue removing wood without the mallet, to shape the area under the lip. If you push...

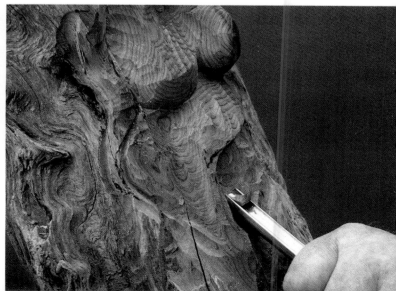

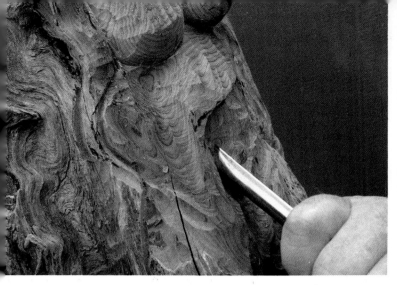

and turn in a smooth motion, the gouge will slice instead of simply chisel, giving you smoother results.

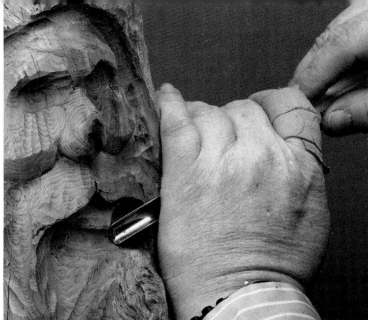

I continue shaping without the mallet. When to use or not to use the mallet is determined largely by trial and error, and I do what works best in a particular situation.

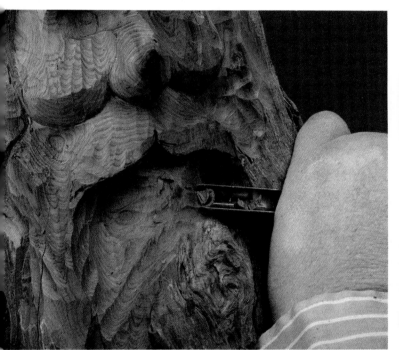

Continue on the other side.

Begin to form the bottom lip by cutting across the grain beneath it, using a mallet.

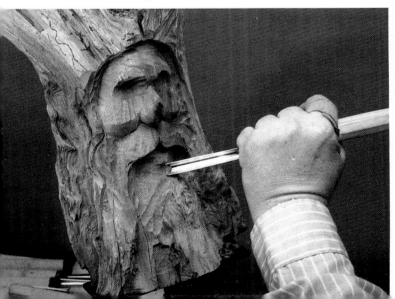

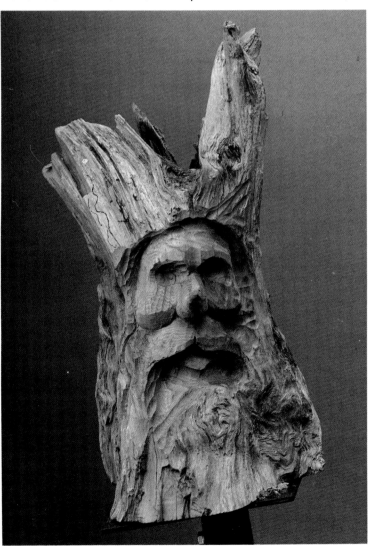

I will leave the bottom lip full like this for a time, which gives me the opportunity to do something creative later.

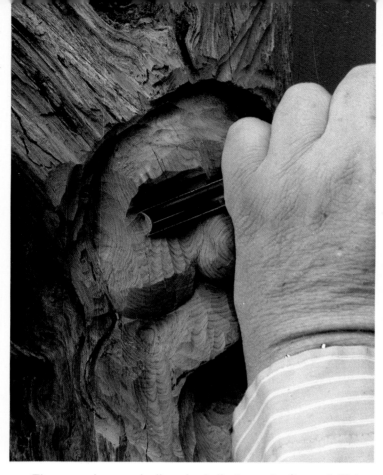

The eyes have a hollow look that we don't want. This comes from the ridge at the outside of the eyes which we remove with the chisel.

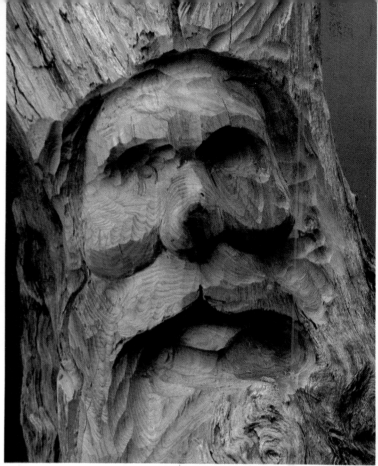

With one eye done, you can see the difference.

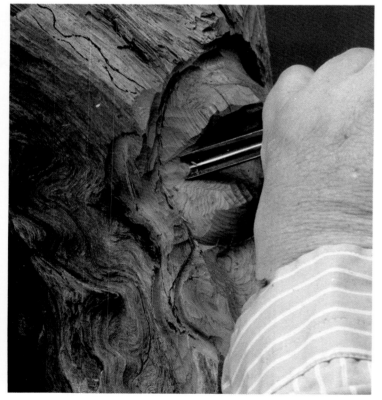

Blend the edge of the eye area with the cheek and into the temple.

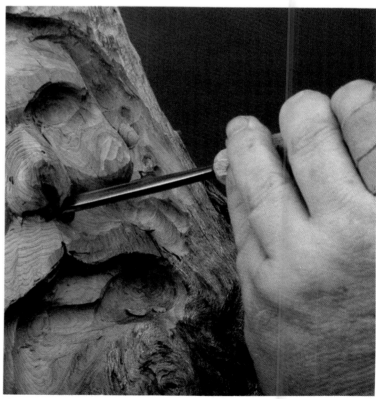

We return to the nose to give it more definition. If you remember, we left it rounded and sized, but rather formless. For this I go to a medium sized rounded chisel to begin to form the nostril. Tap the chisel straight in..

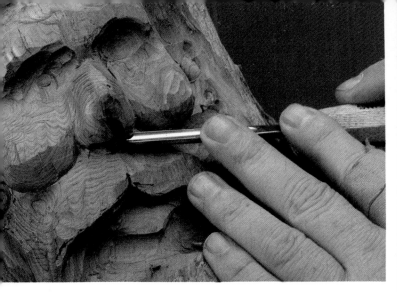

then push back in to clean out the nostril area.

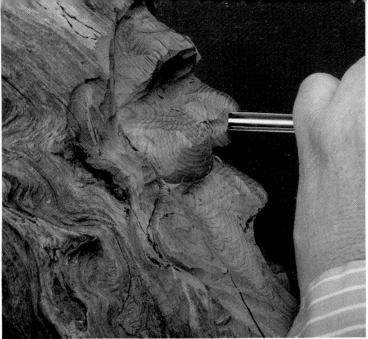

The result.

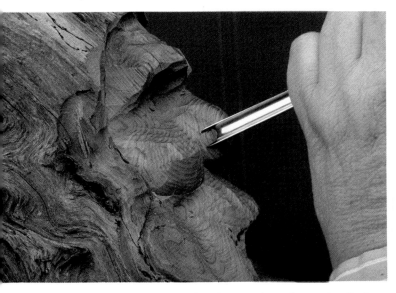

Next we want to create the depression above the flaring of the nostril, push the chisel with the cupped side away from the nose.

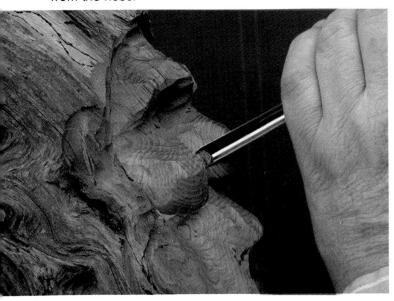

Curve your cut to follow the natural line.

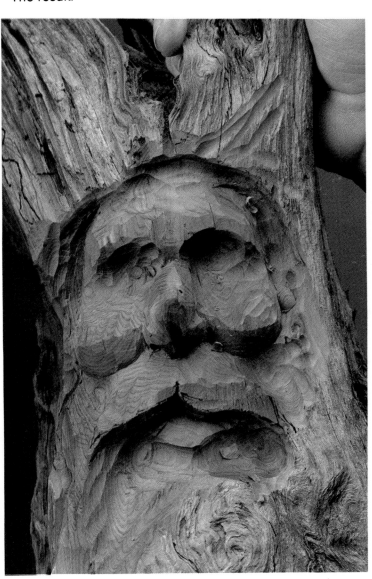

Progress on the nose.

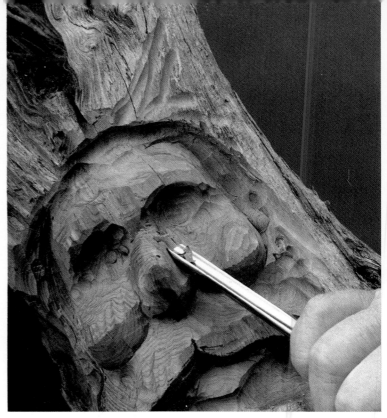

With the cupped side of a larger gouge away from the face, clean up the area beside the nose and the nose itself.

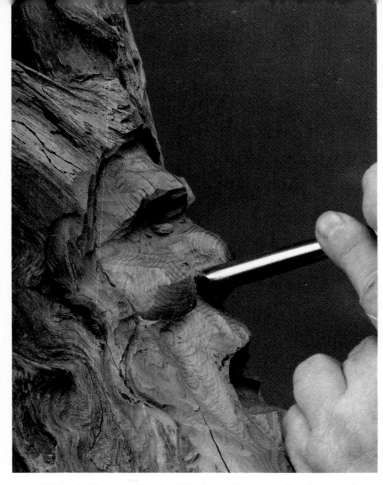

With a half-round chisel that just fits over the flare of the nostril round the back of the nostril into the cheek.

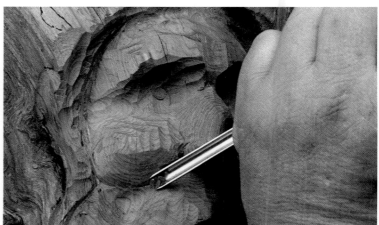

Soften the line of the bottom of the cheek using a gouge.

Continue that line up to along the nostril. You may need to switch to a veiner to fit in this space.

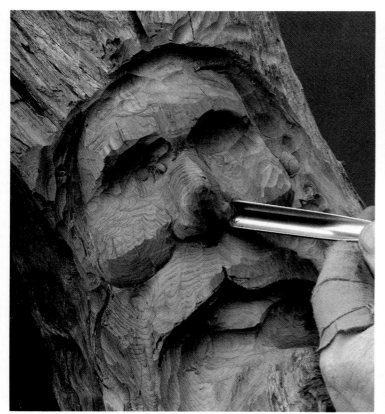

With the same chisel come back to the cut from the cheek to clean it out.

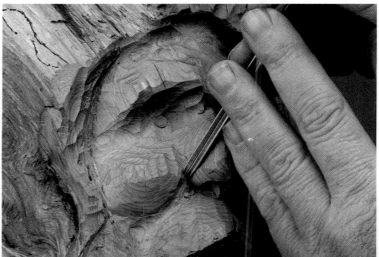

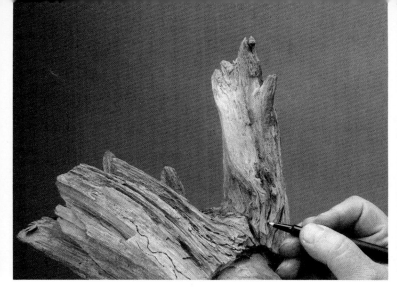

Draw in the major hair lines. Study the piece as you go.

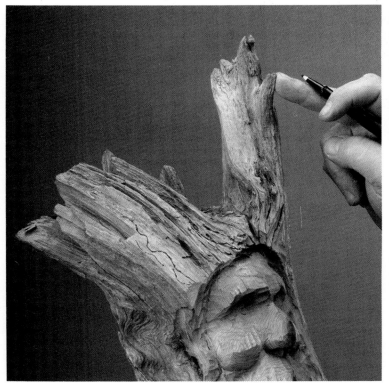

Look for things like these outcroppings that may be incorporated in your design.

Also be aware of little things like this spot which can look like a point where the hair turns into wood.

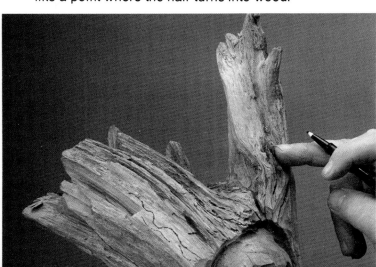

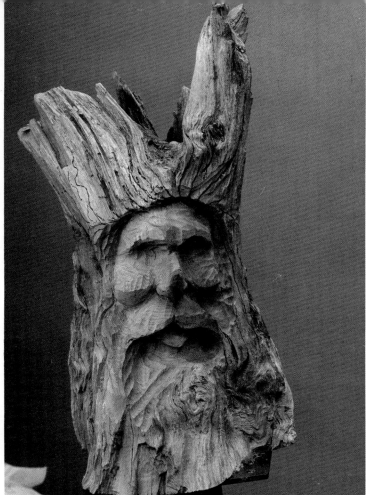

Some of the major lines drawn.

With a v-tool follow the lines you have drawn. On this piece of wood I have some wonderful ridges that I do not want to touch.

23

Move the direction of your chisel to follow the line.

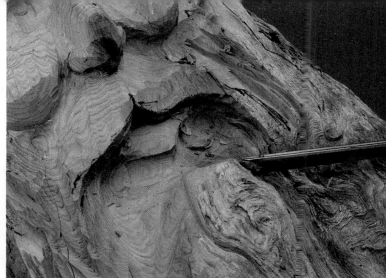

Turning to the beard we want to be careful not to give it an "x" look by adding too much hair to the lower left chin. Instead we want to keep the general flow from upper left to lower right. Use a v-tool on the beard, tying the hair lines together.

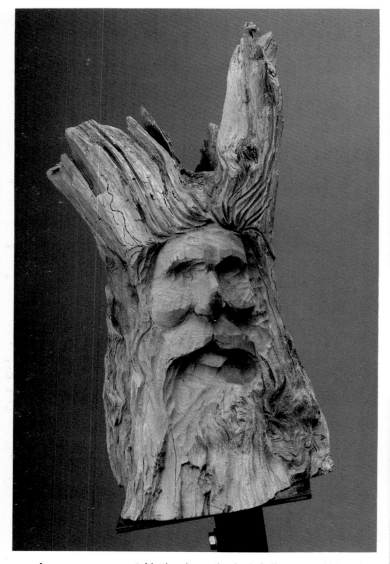

A progress report. Notice how the hair follows and blends with the natural lines of the piece.

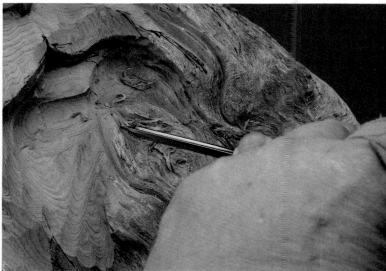

A smaller v-tool gives a finer line. In this part of the carving, I work with the mallet in my right hand, sometimes using it, sometimes not.

This close-up gives you an idea of how the grain of the wood and the carving work together.

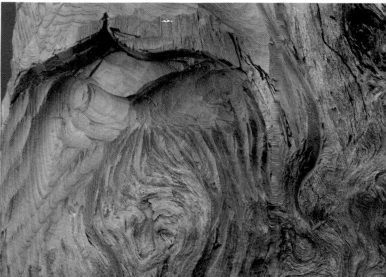

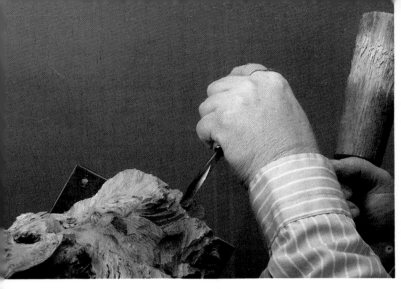

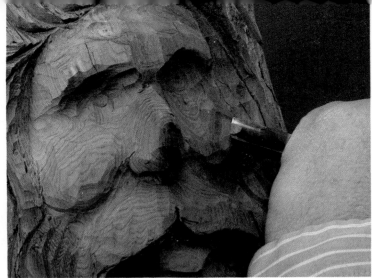

Do the same on both cheeks.

Continue adding major lines to the beard. Don't work too much in one place; move from spot to spot.

With a flatter chisel, smooth and refine the cheeks.

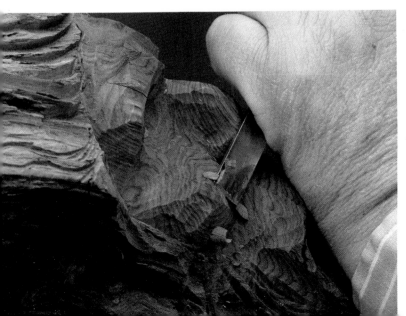

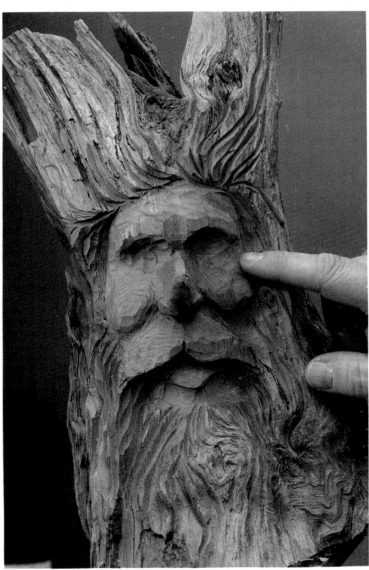

Something doesn't look right, probably in this area here. It's hard to see exactly what is going on. Looking at the piece in the mirror or by squinting your eyes will sometimes change the perspective enough to help you see what the problem is.

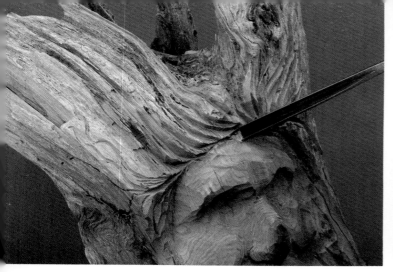

I'm going to fix the line and contour of the forehead and hope that will clarify things for me. I begin with the line where the forehead meets the scalp, deepening it with the gouge.

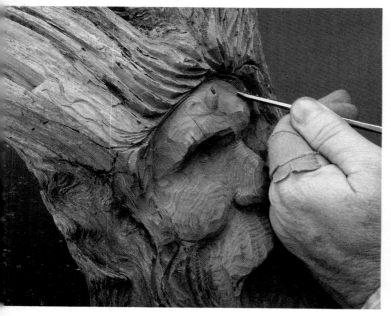

Then I use a flatter gouge to cut the forehead back to that new level.

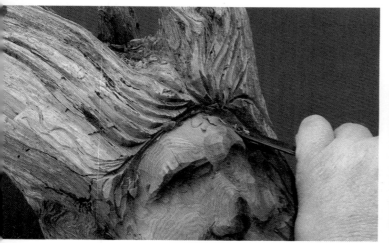

Next I thin the brow a little, using the same gouge.

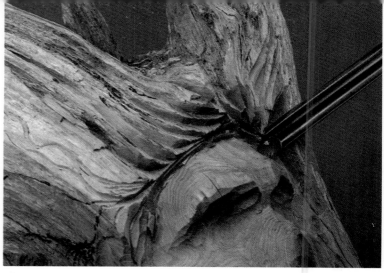

As I look at it I believe it needs a part in the hair somewhere over its left eye.

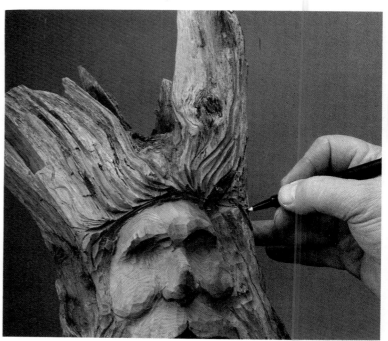

Having done that, the piece still needs something more. I think I want to break the line of the left side of the face in this area.

About one time in a thousand I will use a saw on a Wood Spirit. This is the time. It will give me the nice clean cut I desire.

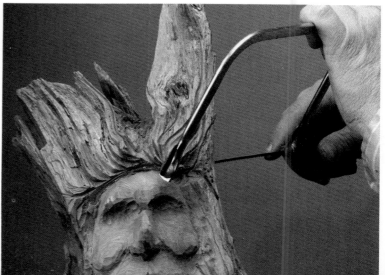

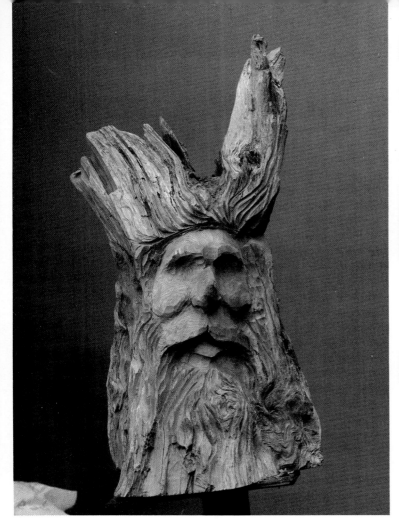

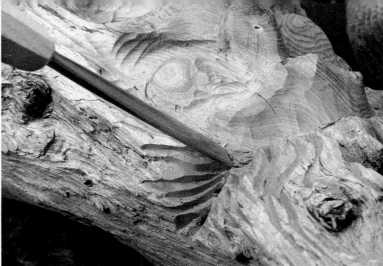

Clean the forehead at the point of the part by cutting a stop along the hairline on one side...

You always take a chance when you do something radical like this, but this time I think it worked. The drama of the piece is enhanced by breaking the line down the side of the face.

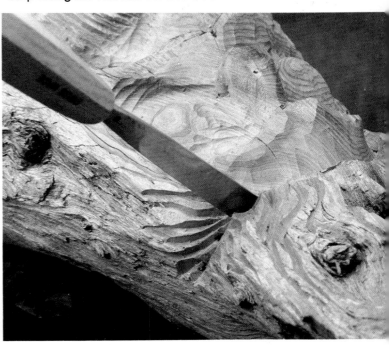

and the other.

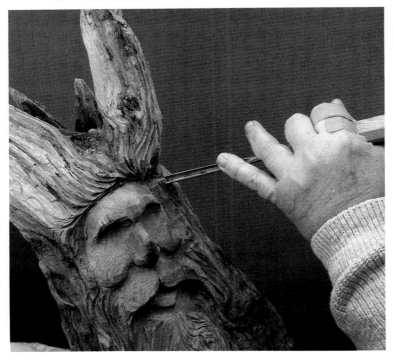

I add some hair lines to the space I have just opened up.

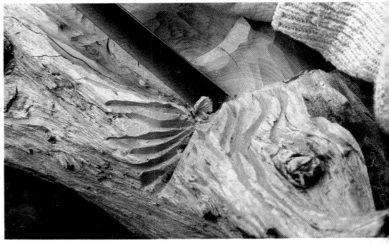

Then cut back into the triangle along the surface of the forehead, removing the waste.

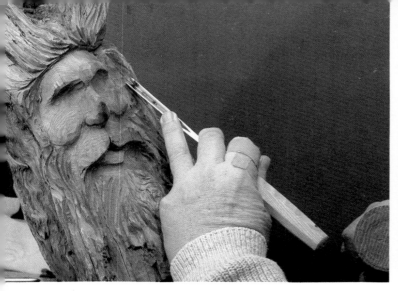

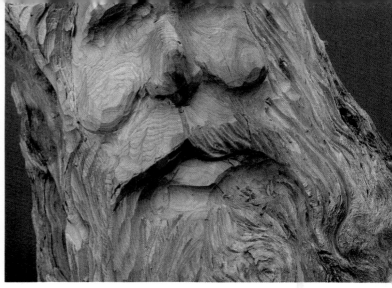

Now we return to the long hairs that we drew some time ago, and go over them with a v-tool driven by the mallet.

to achieve this effect.

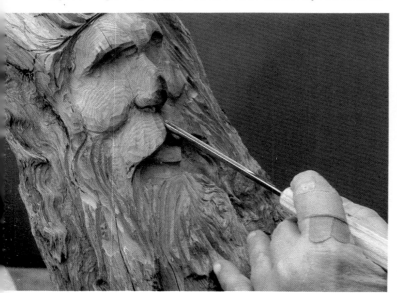

Moving to the moustache, use a large veiner to create the center line.

Then, starting again about half-way down the moustache, push the veiner up toward the nose to complete the carving of the hairs.

Here is one side finished.

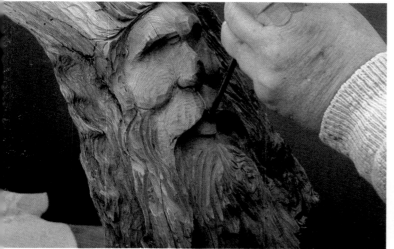

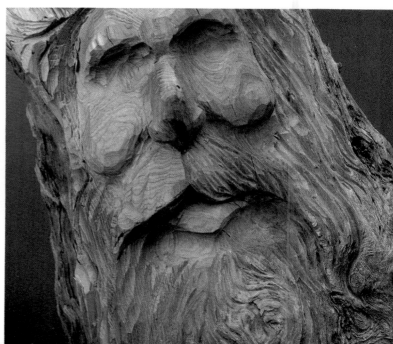

Starting about half-way down the moustache, tap the veiner downward to make the hairlines roll under the bottom...

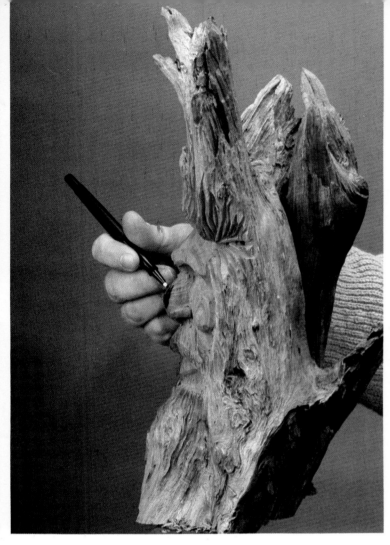

The profile of the Wood Spirit bothers me, and I think it is because the nose is too bulbous. I've marked the area that needs to be flattened.

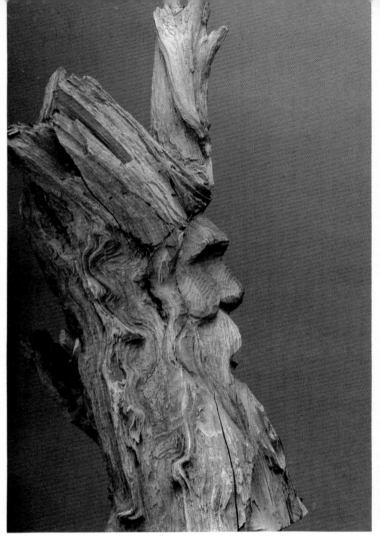

The completed plastic surgery.

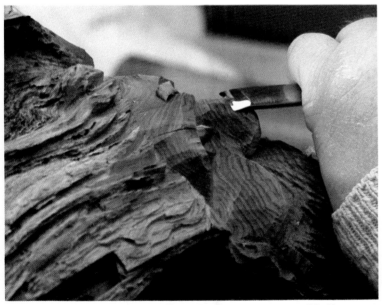

To do the "nose-job" use a flatter gouge with the cup against the nose, and just trim it to the shape you desire. Round and shape it as you go so you don't end up with a flat nose.

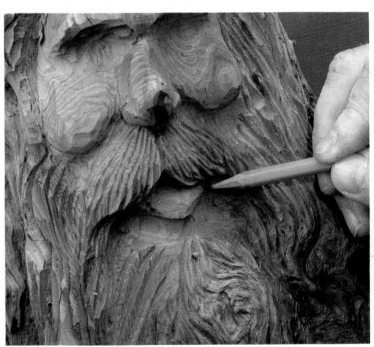

Mark the area of the lower lip. I want the mouth to turn up a little on this side so that the spirit has a kind of sneering smile.

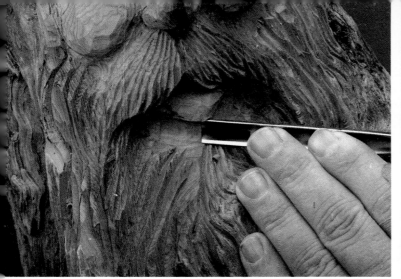

Find a gouge that fits the curvature you want...

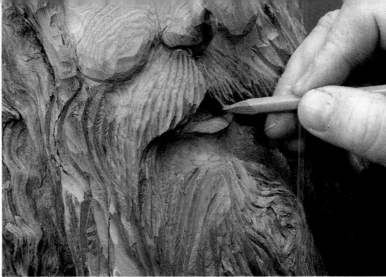

To bring some realism to the lip, I need to carve the inside of it. This will bring it into a better relationship with the moustache and give the carving depth.

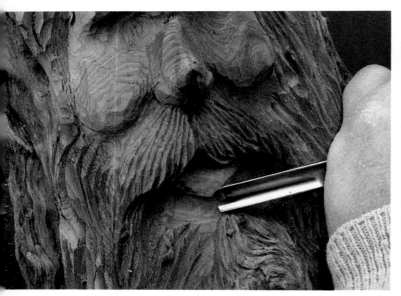

and push it across the grain under the lip.

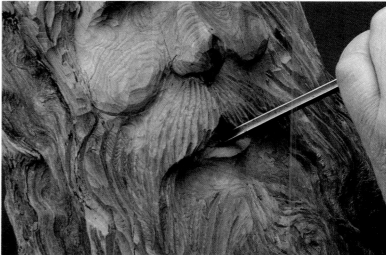

I do this with a veiner to get a good clean cut.

Change to a small flat gouge to clean out the area. This leaves a flat area in case I want to have the teeth show.

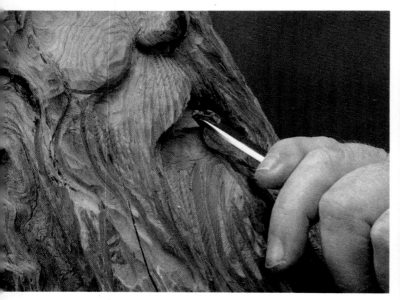

Go over the surface of the lip with a flatter gouge to shape and smooth it.

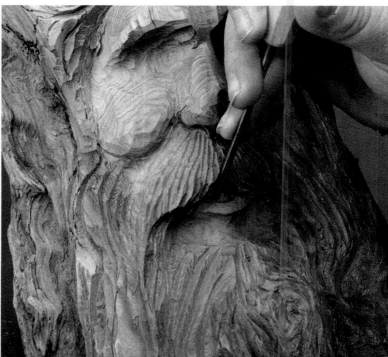

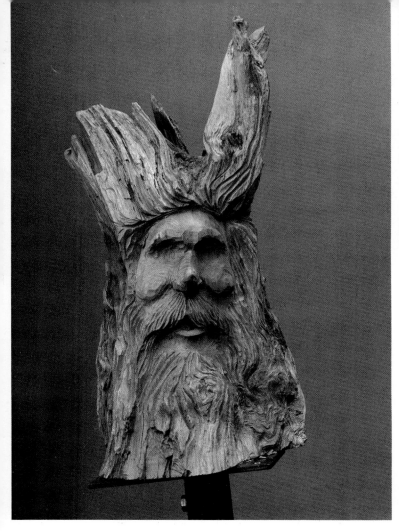

The finished moustache and mouth.

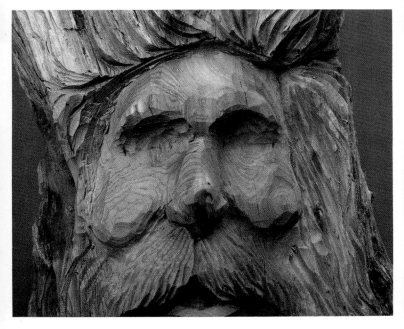

To visualize the placement of the eyes, envision five eyes going from ear to ear. Take away the two end eyes and the middle one and the eyes should have a pretty good placement. Mark the horizontal line of the eye and the ends.

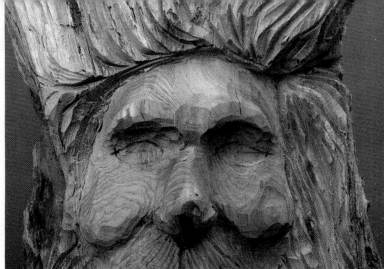

Draw the ovals of the eyes, making them symmetrical. While eyes are not actually symmetrical, drawing them that way now will allow some leeway as you carve.

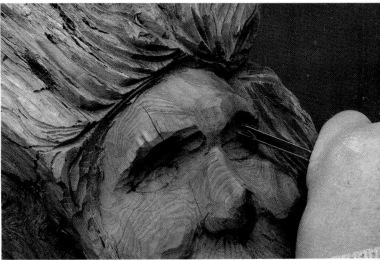

With a large veiner create the eyelid by following the upper line of the eye, but about an ⅛" above it. I use a veiner here because the shape of the tip protects against cutting into the wood, which a v-tool might do.

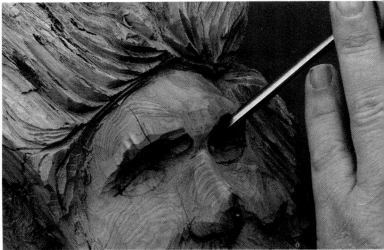

Carry the line down into the inside corner.

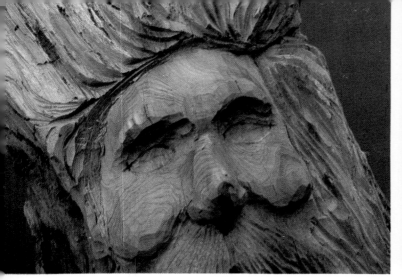

The result.

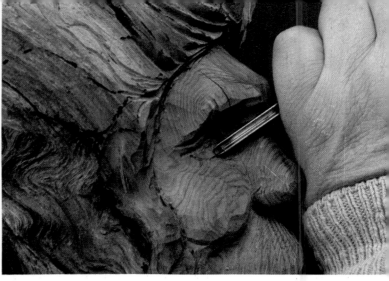

Now go across the eye, along and slightly inside the lower line.

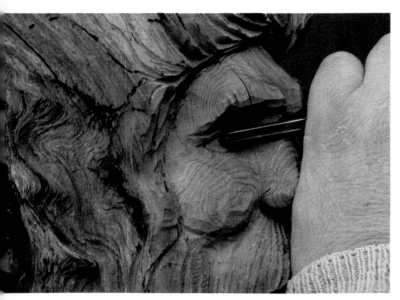

Using the same tool come across the eye again, going just under the top line you drew. Most of the line should remain.

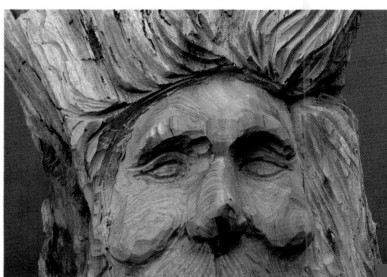

Progress so far.

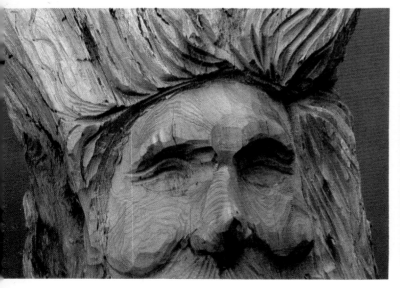

Notice how the eyelid is left after these two cuts.

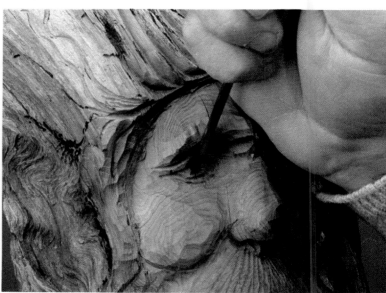

Use a small flatter gouge to clean the surface of the eye. Follow the contour of the eye.

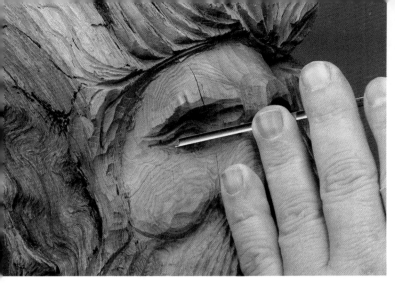

Work into the corner of the eye.

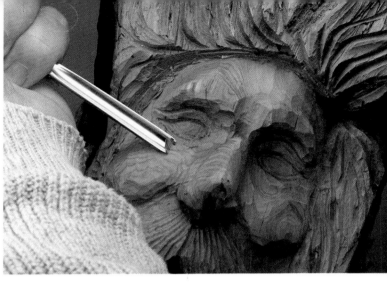

Cut so the line goes right up the center of the chisel.

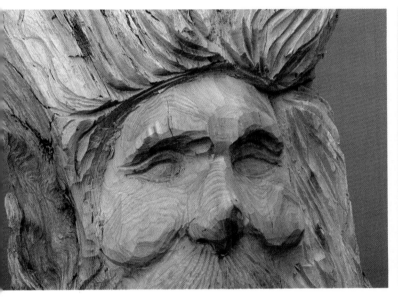

The shape of the eye is established.

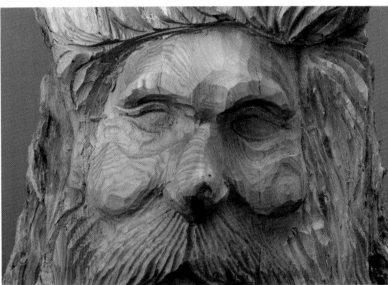

The result of that cut. It will be smoothed and blended later.

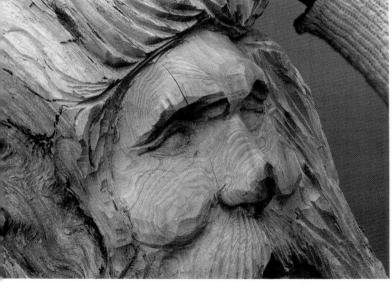

Now use a small half-round chisel to create the bag under the eye. This is the line you need to follow.

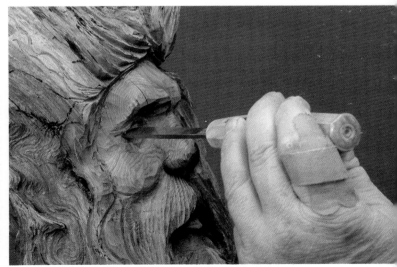

For now let's go back and set the outside corners of the eyes, giving them depth. Using a skewer chisel create stops by pushing it straight in along the line of the top lid...

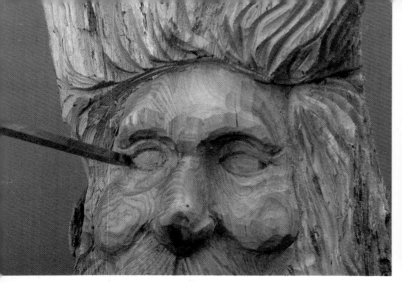

and the bottom.

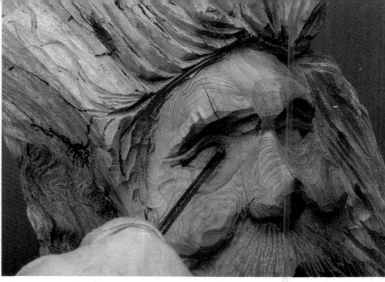

and the bottom.

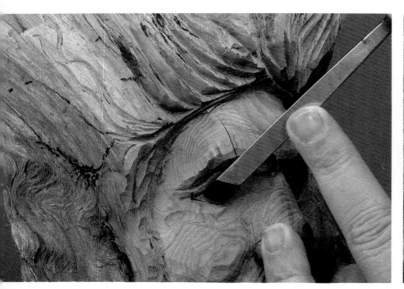

Come across the eyeball into the corner. You want this nitch to fall out, not be pried or forced, so you may have to repeat these steps more than once.

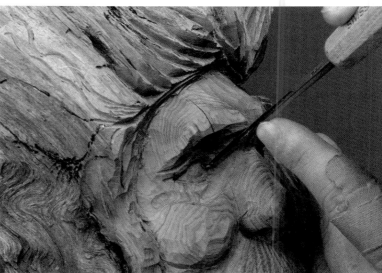

The come along the side of the nose into the corner.

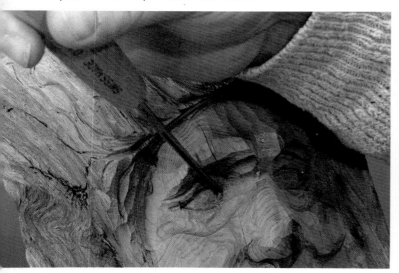

Because it is more delicate I will use a veiner for the inside corners of the eyes. The procedure is similar. Follow the top line toward the corner...

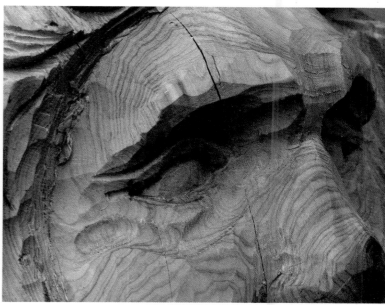

The last cut not only cleans up the corner, it leaves the little line at the corner which we need for realism.

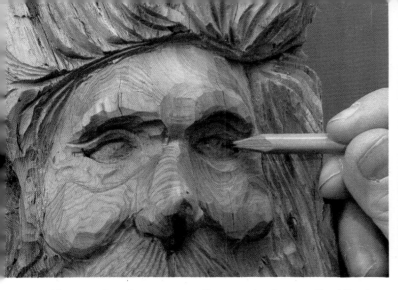

You can hardly go wrong if you make the pupils at the top of the eye and slightly toward the center.

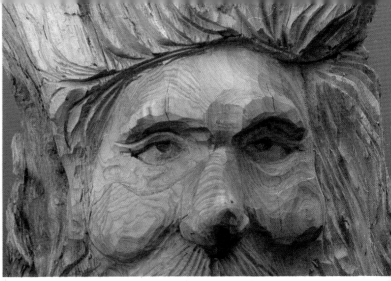

The eyes so far. This hollowing is a stone sculptor's trick. The play of the shadows gives the illusion that the eyes are following you.

Take a half-round gouge to fit the lines you have drawn and go straight in. To prevent breaking the eyelid, don't twist your gouge or hit it with a hammer.

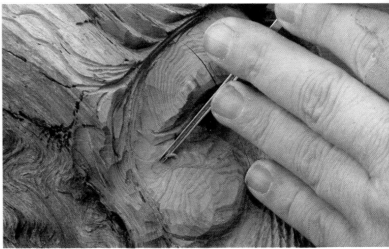

Use a veiner to create crow's feet at the corners of the eyes.

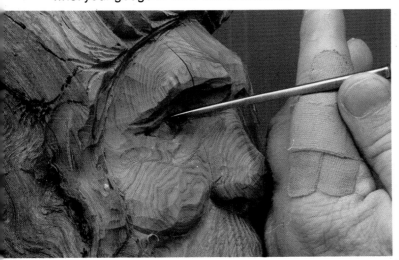

Now, with a flatter gouge go straight in under the lid at the top of the pupil. You are trying to clean out the pupil area, making it hollow. To do this push in with the flat gouge until the excess falls out. Be gentle.

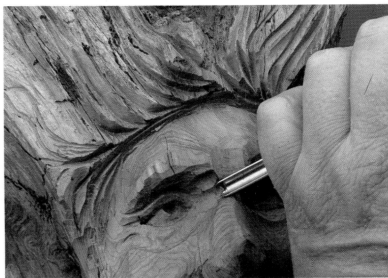

I don't like the heavy lines at the bridge of the nose, so I just smooth them off. I will however leave the eyebrows heavy, giving the piece a lion-like, animalistic look.

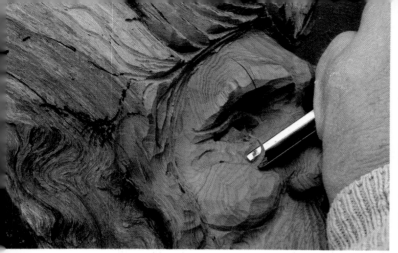

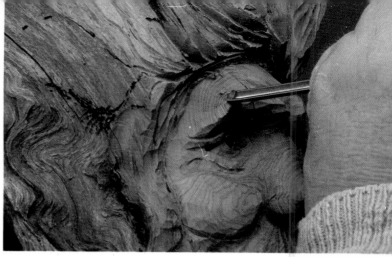

Refine the piece, taking off sharp lines and generally smoothing the face. Flat gouges...

Move to the eyebrow and add the hairs using a veiner. Don't follow a set pattern. Instead change the direction of your cuts to get a bushy, unkempt look.

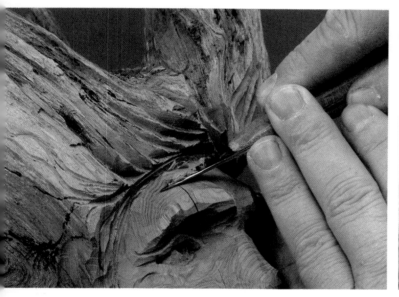

or knives are good tools for this refining process. I like a knife with a turned-up tip, in this situation. Paying attention to this smoothing step may save you a lot of tedious sanding.

Add lines to the beard. I like to use a veiner rather than a v-tool because it gives me softer lines and a look I like.

The technique for the beard and hair simply involves finding big bold places and make them soft and detailed. Blend the lines, making them run together and intersect. While doing this keep your eye open for any ink or pencil marks from earlier and "erase" them.

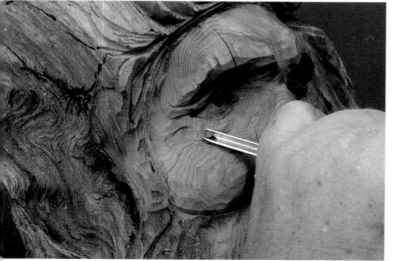

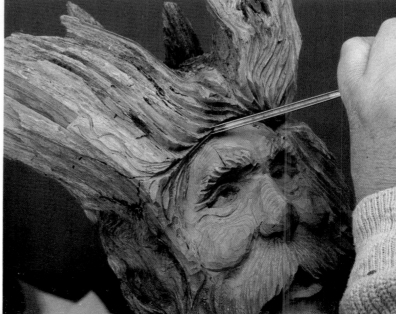

One of the details we can add now is an accentuation of the bags under the eye. I use large veiner for this.

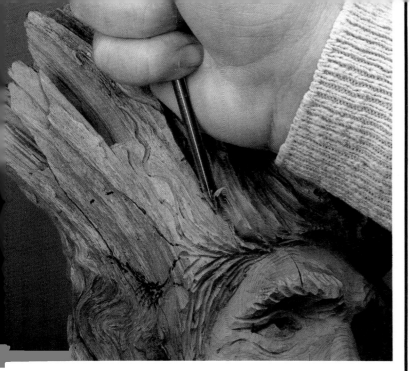

Take advantage of the natural flow of the wood, but add some interesting touches of your own.

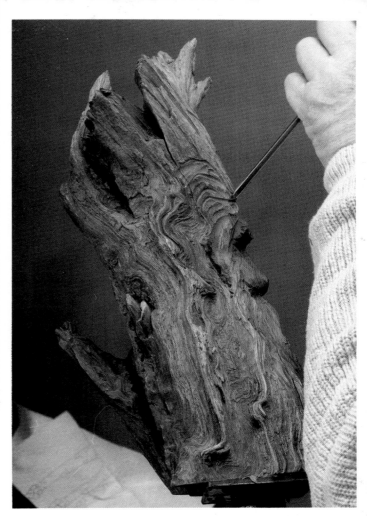

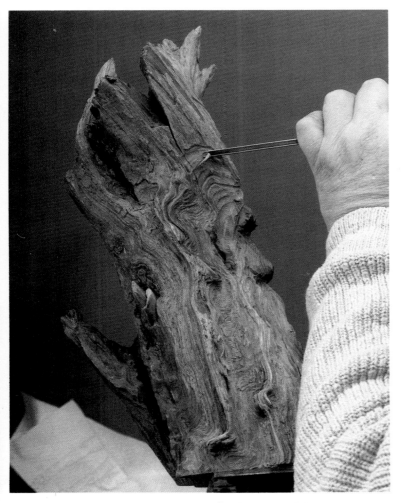

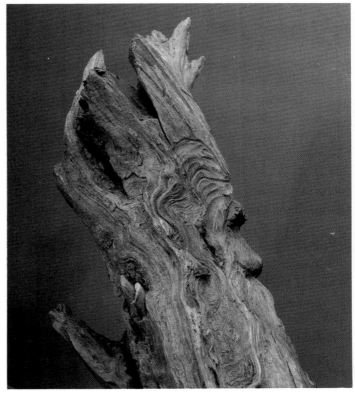

On this side of the face the natural lines are so wonderful that all I really need to do is create the lines that will blend and integrate them into the whole.

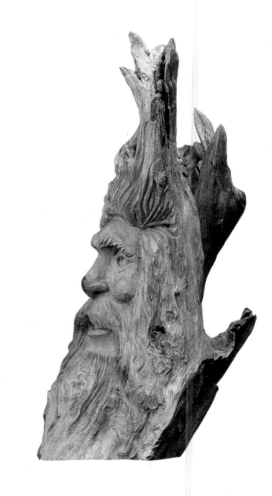

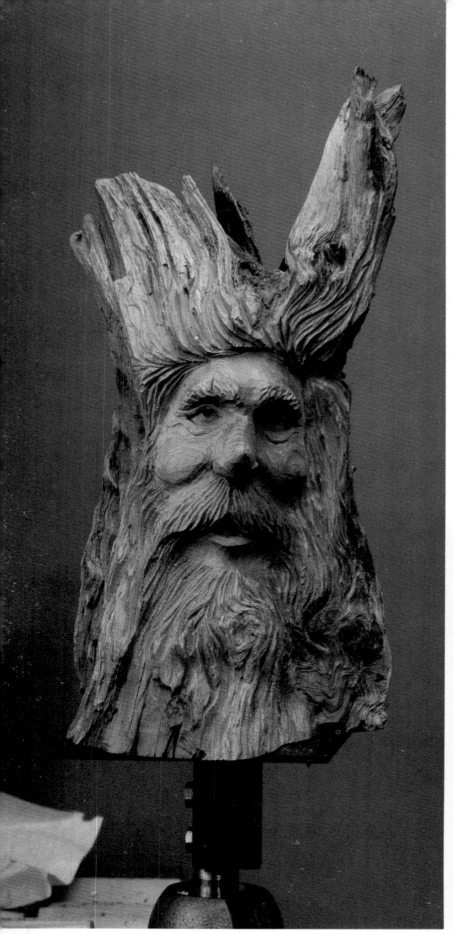

The finished piece.

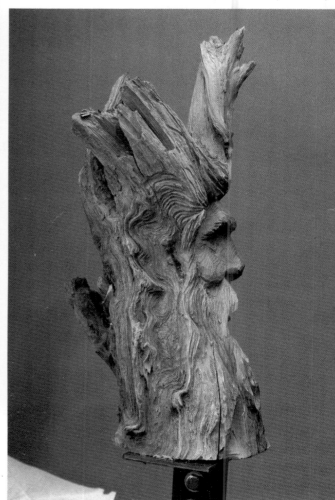

The Walking Stick

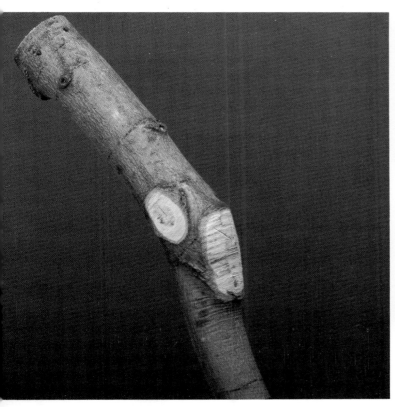

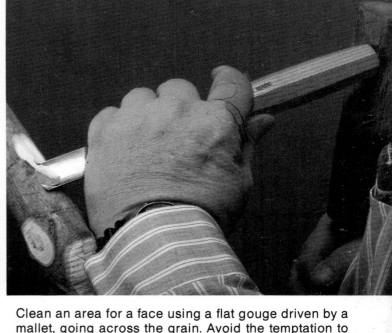

Clean an area for a face using a flat gouge driven by a mallet, going across the grain. Avoid the temptation to make the face on the crook of a bent piece.

This is the wood before we start. It is green maple sapling. You need to find wood that will dry without cracking. In the mountains maple, all the birches, and especially mountain black birch and sour wood work well. In the lowlands sweet gum works nicely. Usually the wood that is most prolific is the best. A straight piece is fine, and many hikers prefer it straight. But a crook like we have here will make the carving more interesting.

We don't want the black knot to be on his nose, so I'm clearing enough area so we can place it in his mouth.

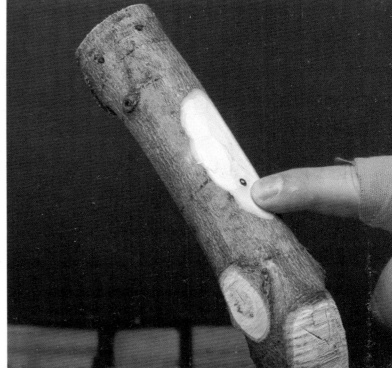

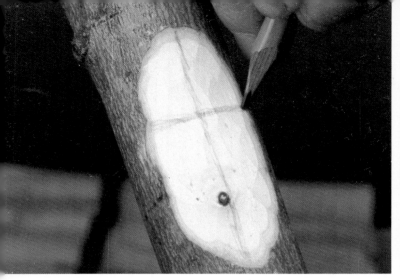

Mark the center line and the line of the eyes.

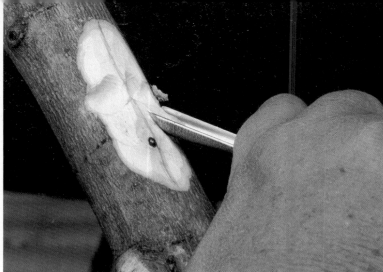

Come up beside the nose to bring it out.

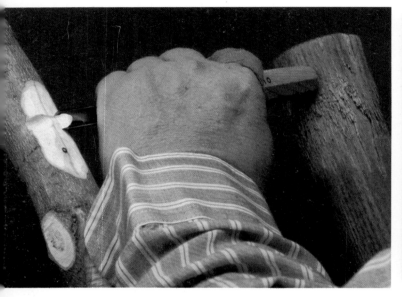

Gouge out two eye sockets using a half-round gouge. I start it with the mallet...

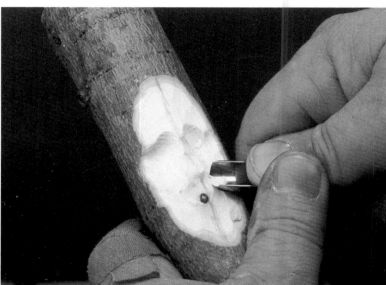

Clean out the cheek area.

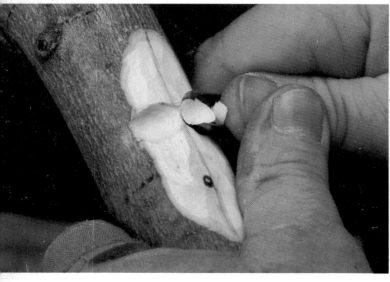

and finish it without. Note the thumb position, which gives added control over the cut.

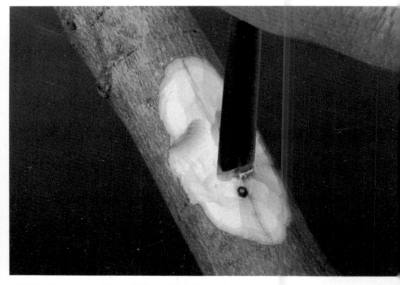

With the cup side of the chisel against the nose and the end at the bottom of the nose, drive the chisel into the lip to form a stop at the bottom of the nose.

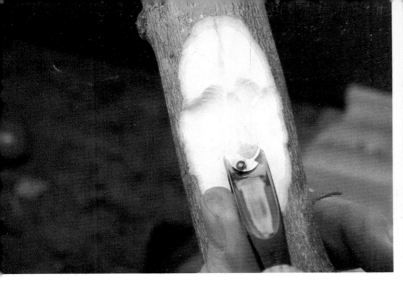

Cut back to the stop from the lip.

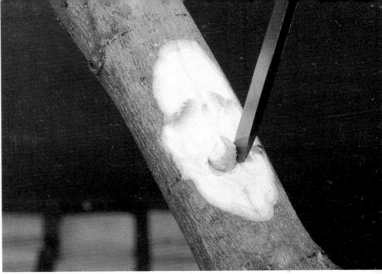

Using the same tool cut a stop beside the nostril...

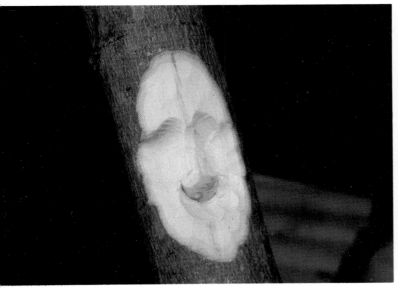

The nose is formed.

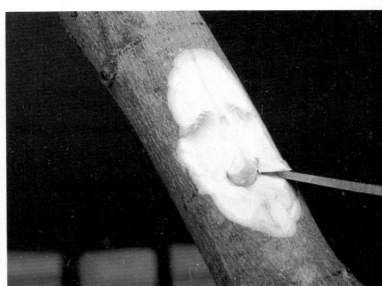

then chisel back into the stops.

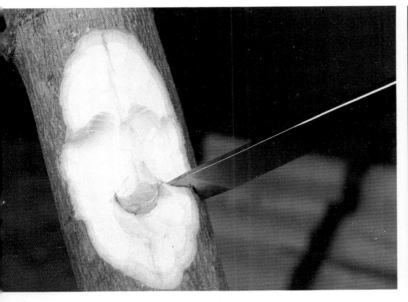

The next stop cut goes along the line between the cheek and the moustache, using a flat skew.

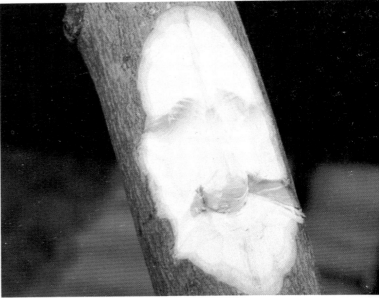

This forms the shape of the cheek and the moustache.

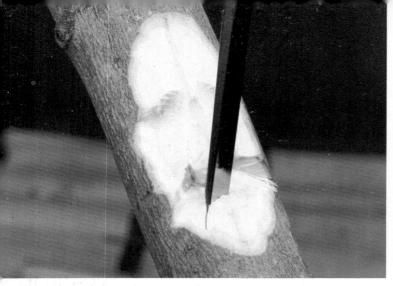

Using a flat sweep chisel, a quarter inch or so wide, drive into the bottom of the moustache to form that line and the line of the lip.

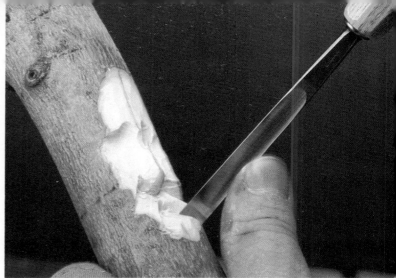

Clean the lip area using the chisel without the mallet.

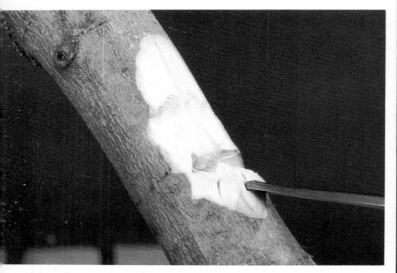

Come back to the line with the cup side of the chisel down against the surface of the lower lip.

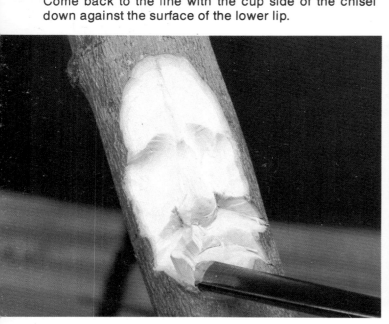

This will form both the lip and the moustache.

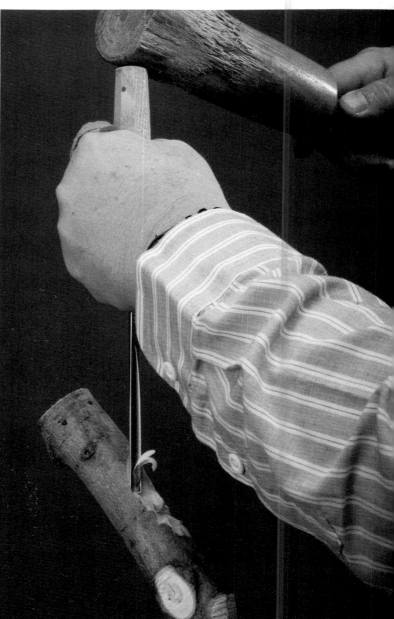

Use the v-tool to define the outline for the face.

Go down the side of the face and into the beard.

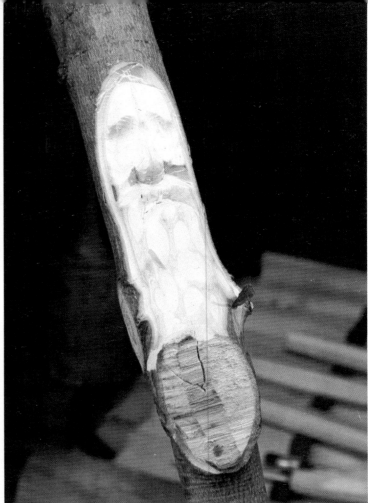

The face so far.

As you come into the beard, change the direction of the chisel to create flowing lines.

When the outline of the beard is established, go back with the flat chisel and remove the bark in the area of the beard.

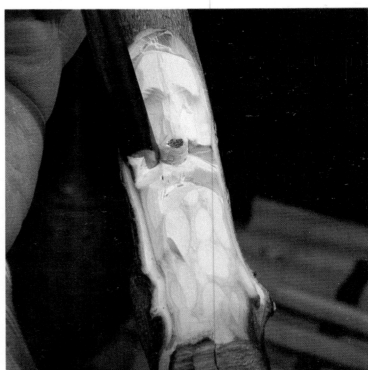

With the cup of the chisel against the cheek, drive it down toward the jaw.

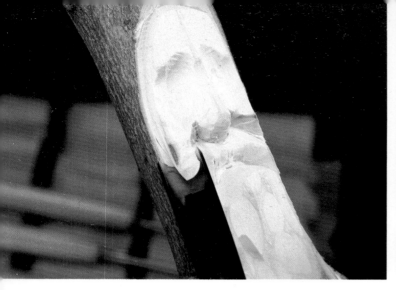

With the cup up, drive it back toward the cheek.

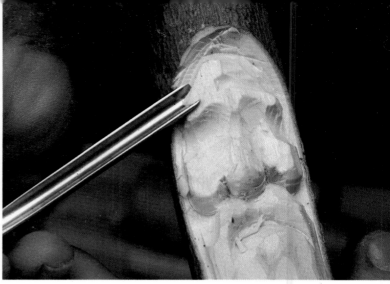

Use a small half round chisel to remove wood from the forehead, forming the eyebrows and rounding the forehead as you carve.

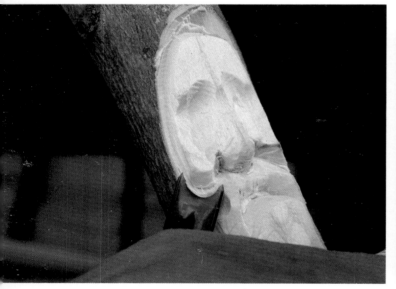

Repeat this until the wood is free and the cheek is formed.

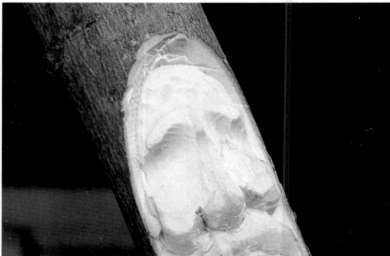

The forehead and temple areas.

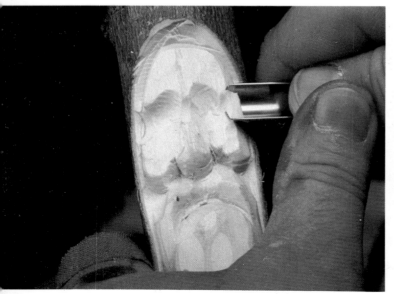

Form the temple area by using a gouge with the cup away from the face and pushing it forward.

Using the same half-round chisel, with the cup side out come down between the eyebrows.

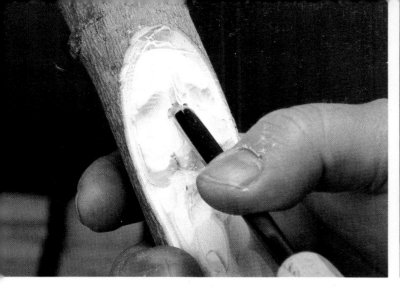

With the cup against the nose cut back up until the wood between the eyebrows pops out.

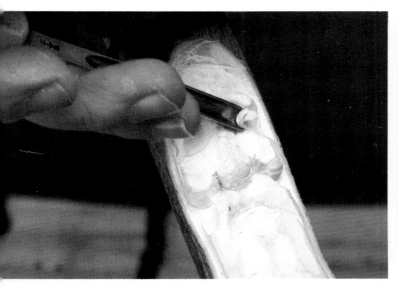

Coming down and across from the bridge of the nose, deepen and define the eyesocket. When using a gouge, always try to go across the grain.

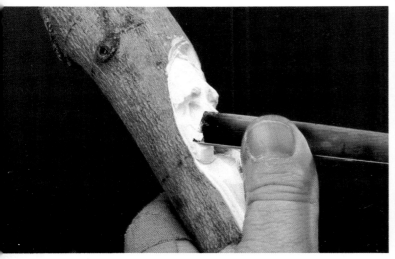

Use a flat gouge to clean things up all over. Sometimes you will have the cup side up, other times it will be better against the work.

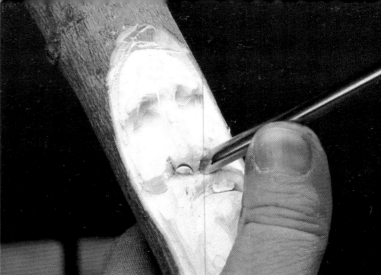

Use the half round chisel with the cup away from the nose to form the nostrils.

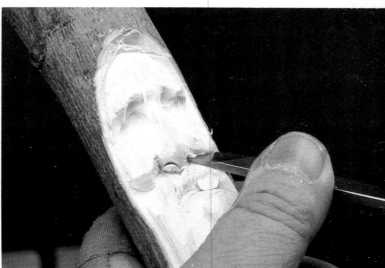

Clean out the excess with the skewered chisel.

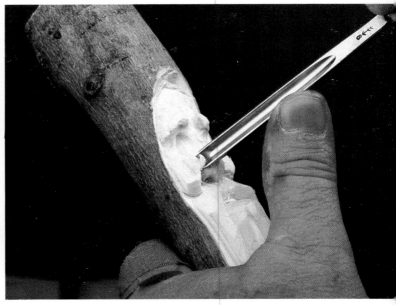

Use the half round to flair the nostril.

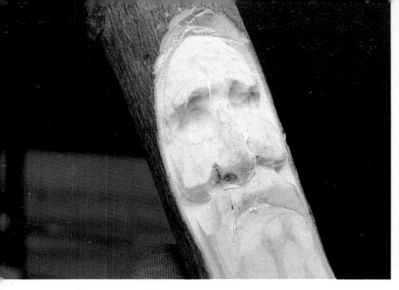

This gives this effect.

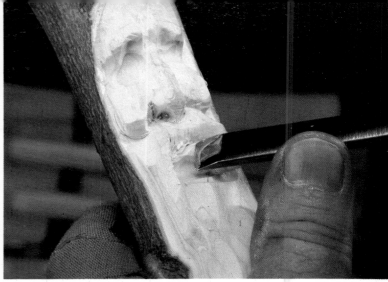

Come back to it along the bottom lip.

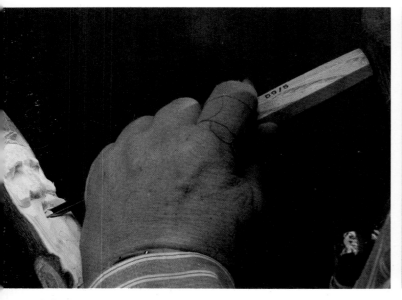

Cut under the bottom lip with the gouge to bring it out and define it.

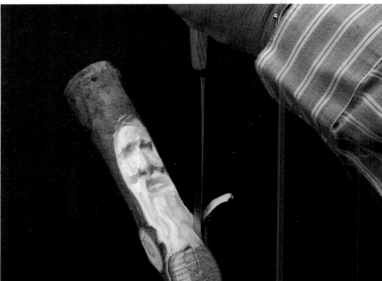

With the v-tool driven by the mallet, create the beard line coming down from the mouth area. You can create curves by rotating the tool, make it go deeper by lifting it up, or make it shallower by moving it closer to the face.

Add more beard lines. It is best to move around the beard bringing some down here and some down there, some deeper, some shallower. After the major lines are established you can bring them together.

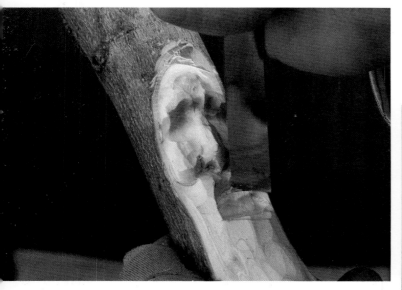

To clean up the mouth use a flatter gouge along the bottom of the top lip to create a stop.

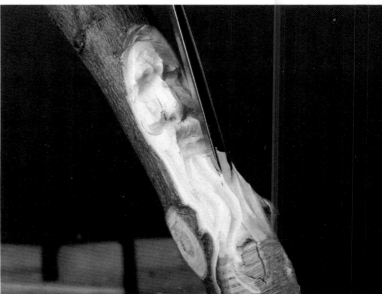

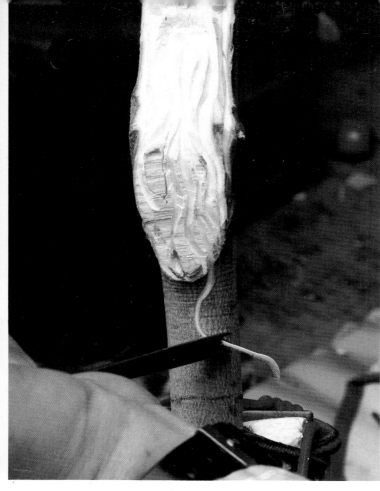

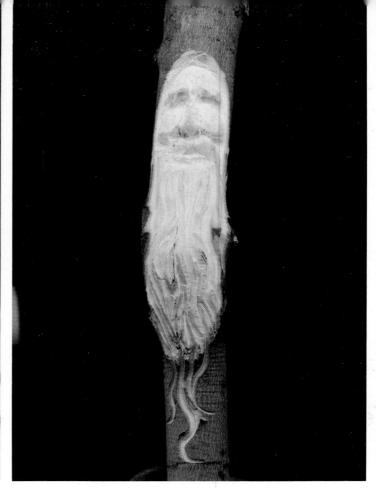

I like to bring some of the lines down into the bark area. This gives the piece more character.

The beard takes shape. When using the chisel, the piece is pretty much finished as it goes.

I can either leave the top of the head as it is, giving it the look of a hood, or add some flowing locks. For this carving, I'll leave the hood, but others in the gallery have the locks. The technique for the hair is much the same as for the beard.

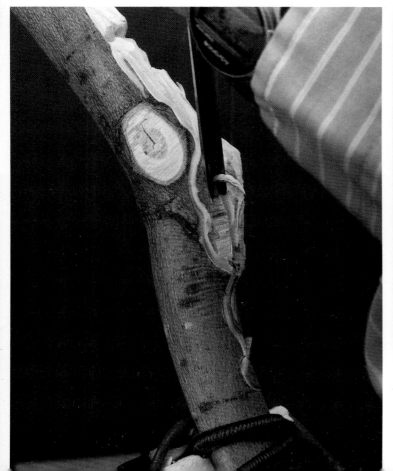

I will add some locks of hair around the face.

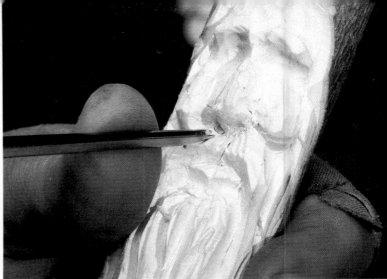

Clean the face using a half round gouge and hand pressure.

and the moustache.

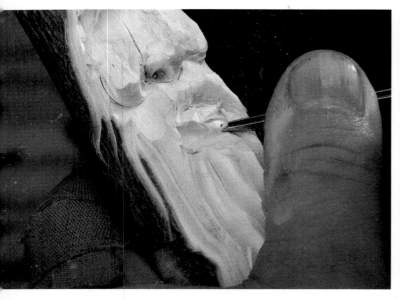

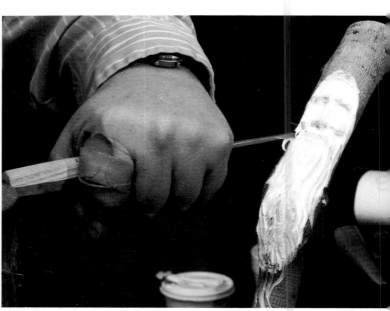

Using a small veiner, go between the major hairs of the beard...

At times you will need to push the chisel by hand. Other times, especially when you want a long, flowing line, you'll want to drive the chisel with the mallet. This is called the chase method, because you chase the chisel through the wood.

For a short hair like here in the moustache, I move the chisel by hand, giving it a little wiggle to make it walk.

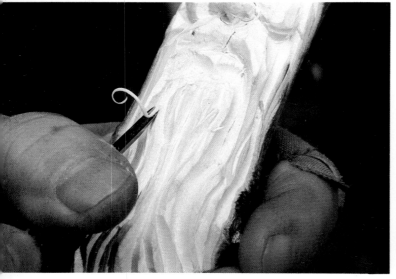

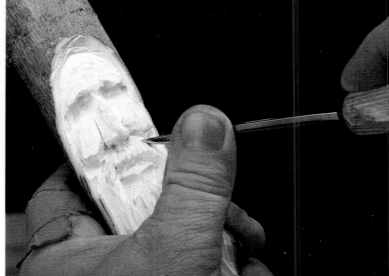

and add more detail to it...

For a longer hair the mallet helps me get the uninterrupted line I want.

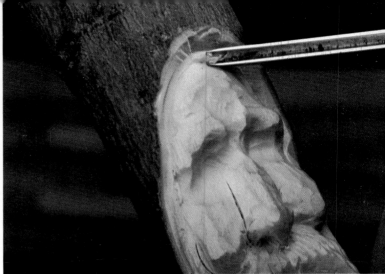

Use a v-tool to create a wisp of hair showing beneath the hood.

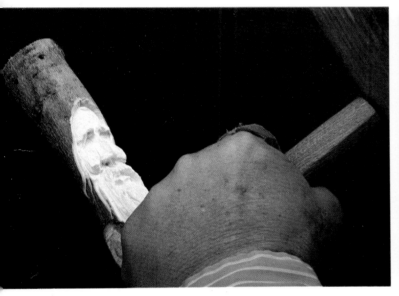

When using the mallet, hitting with the lower portion gives you a good solid stroke. This is good for taking off excess wood, but doesn't give much accuracy.

As you move toward the tip of the mallet you get a gentler, faster stroke that gives greater accuracy. Hitting in between will give you variations of these two extremes.

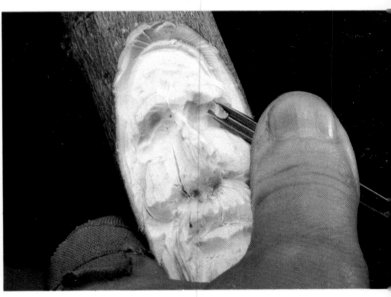

Use a larger u-shaped veiner to define an eyelid underneath the brow and above the eye.

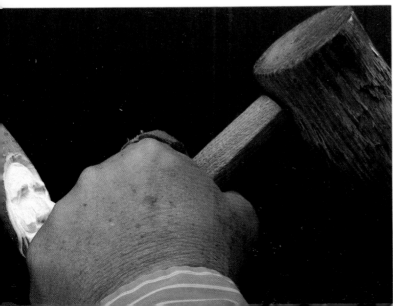

With the same tool create the eye slit.

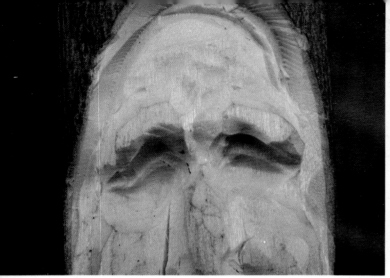

The eyes so far.

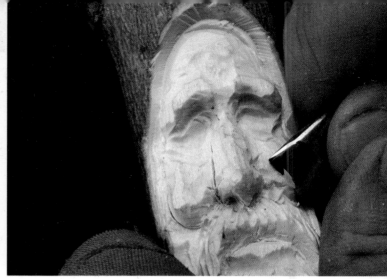

With a flatter gouge, place the cup against the face and smooth the high and rough spots.

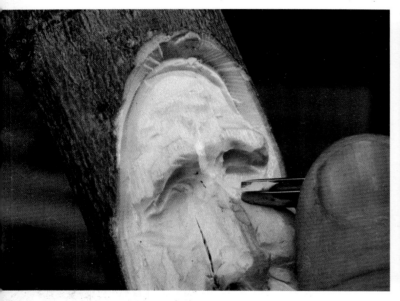

Now we come underneath the eye with the same tool to shape the bags.

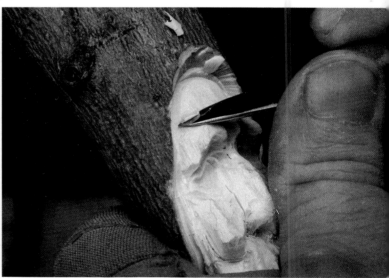

You can also use a knife for this smoothing process.

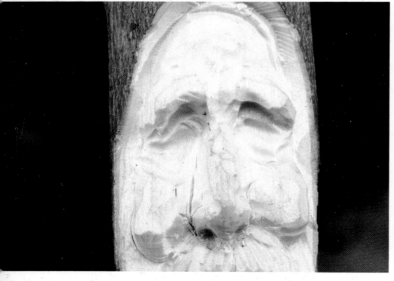

The bags. As you can see there are some pretty craggy places that need to be smoothed.

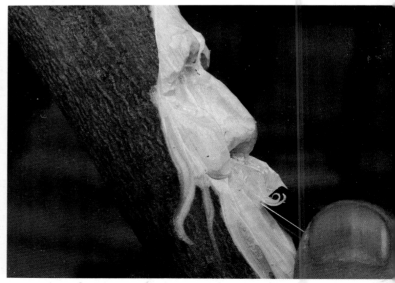

As you go over the piece you may find things you don't like. The right side of the moustache comes out too far for me, so I am going to trim it down a little and redo the hairs.

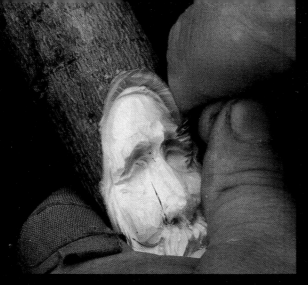

For finishing touches I will add hair lines to the eyebrows with a fine veiner.

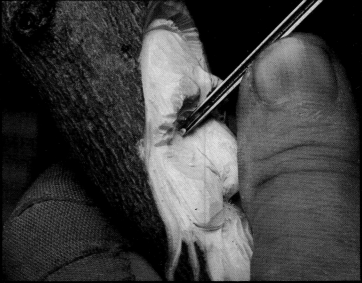

and the inside to create a hint of the iris.

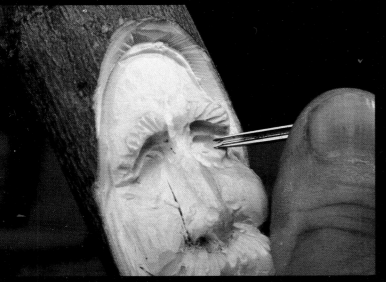

On the eyes I use the same veiner and come in a little bit from the outside...

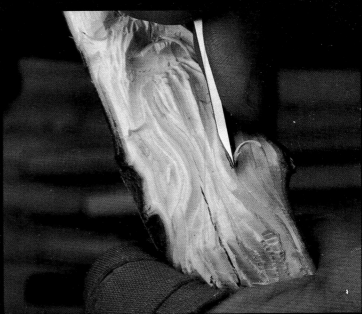

I use the same veiner to break up large flat surfaces in the beard with added hairs.

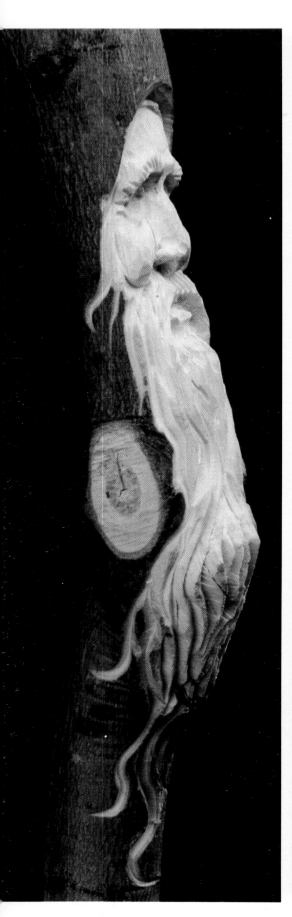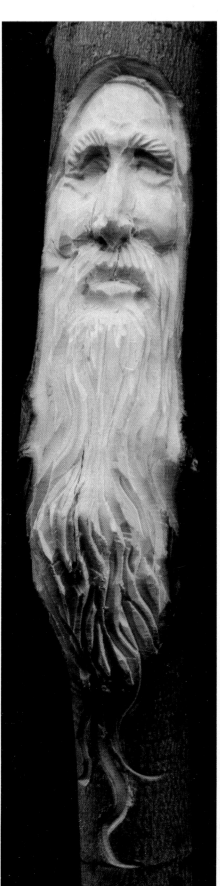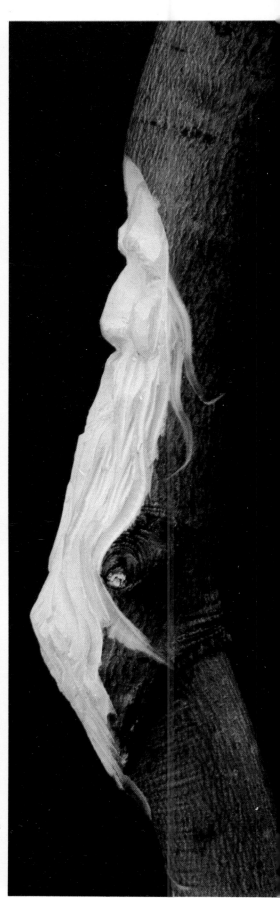

The carving is finished.

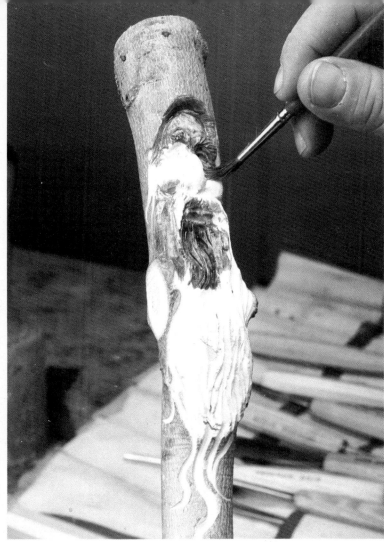

I will finish this with a wash of alkyd burnt sienna paint in turpentine, although a commercial stain would work as well. The stain will seal the wood a little, retarding some of the cracking process. It is, of course, possible to paint the spirits, or to leave unfinished with a coat of linseed, tung, or mineral oil for protection. If you get any of the stain on the bark, just blend it in.

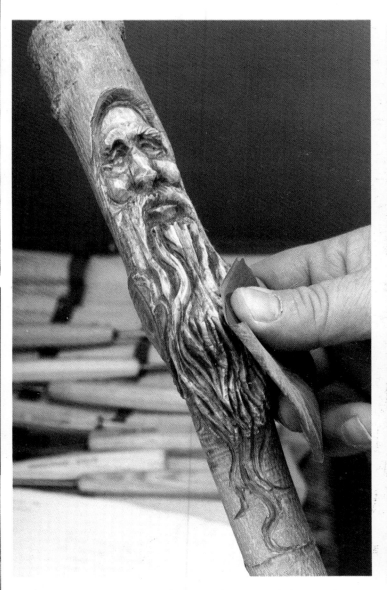

If you wish you can use a fine sandpaper to bring up the highlights.

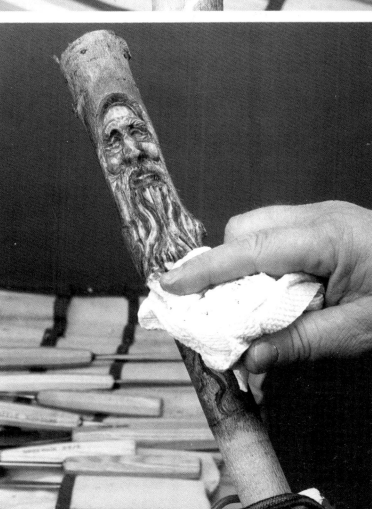

Wipe off the excess with a paper towel or rag to bring out the highlights.

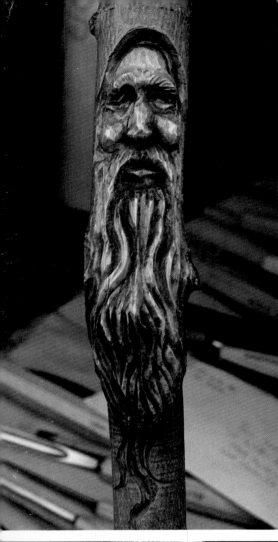

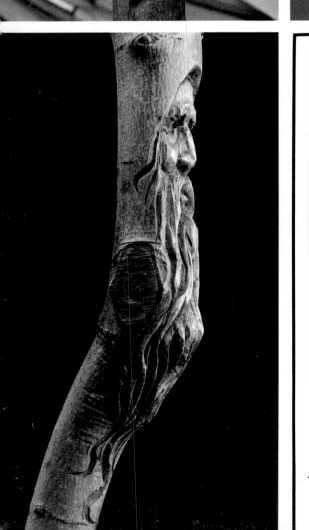

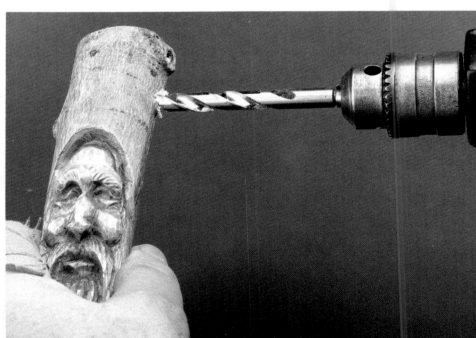

The last thing do is drill a hole through the top of the stick for a leather thong. In addition to being a convenience for the hiker, this also seems to reduce the checking and cracking of the wood.

The finished piece.

Gallery of
Wood Spirits
and Walking Sticks

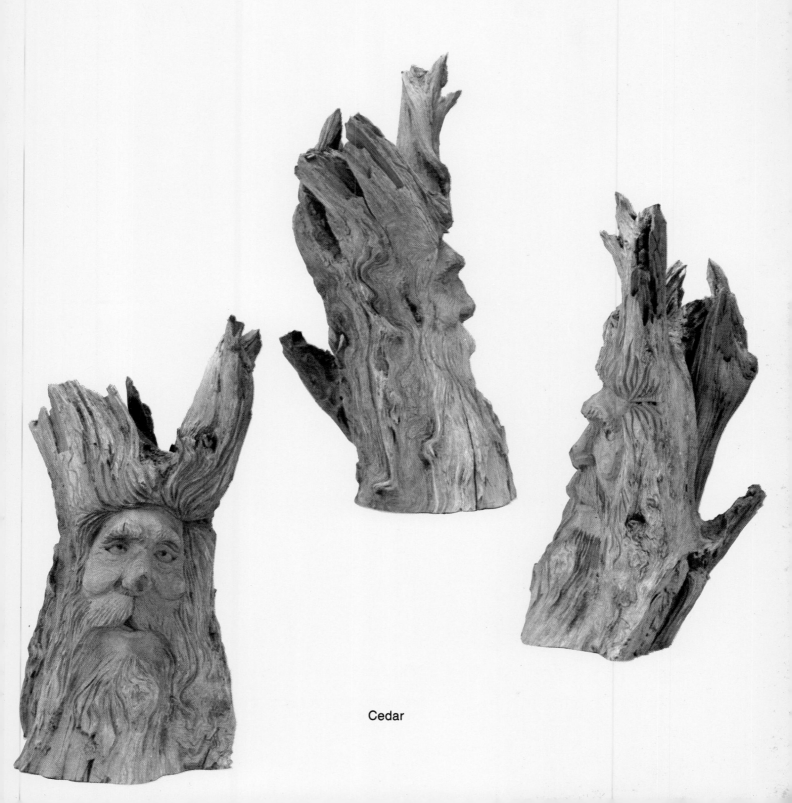

Cedar

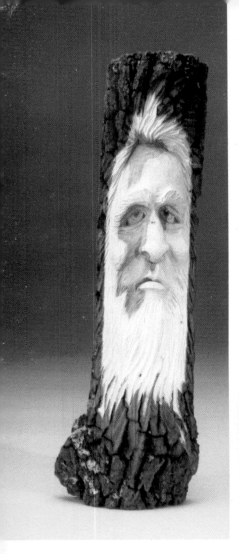

Sourwood

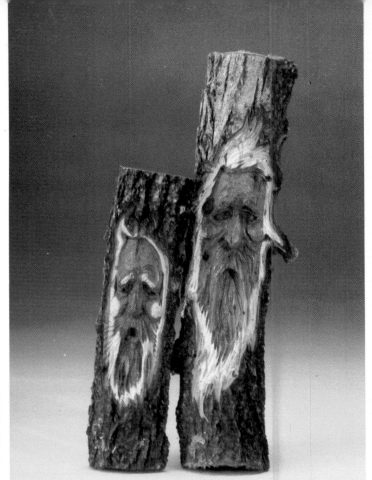

Elm carved by leaving sap wood to bring out color.

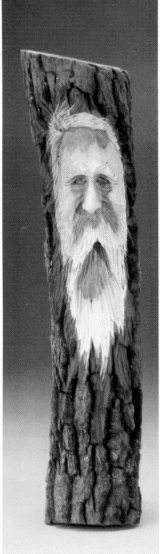

Sourwood

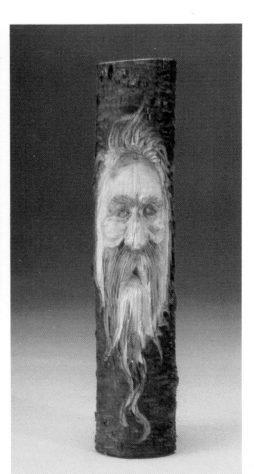

Choke Cherry

56

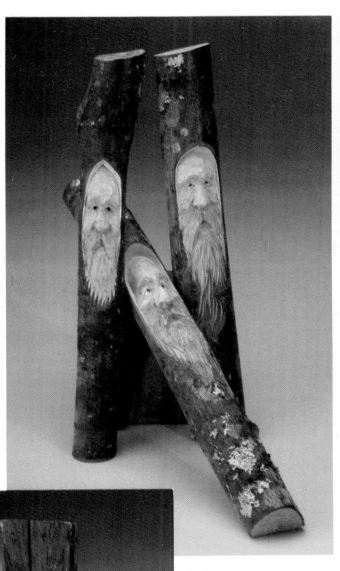

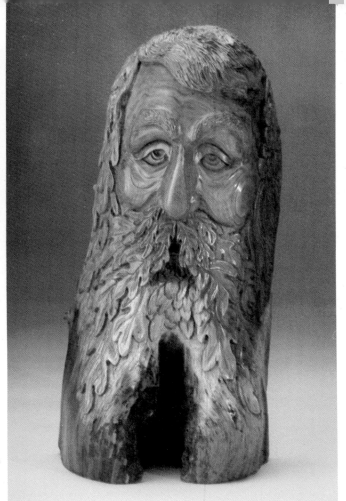

Butternut Jack 'O the Green, English type wood spirit.

Painted maple.

Oak House timber.

Carved from an oak house timber.

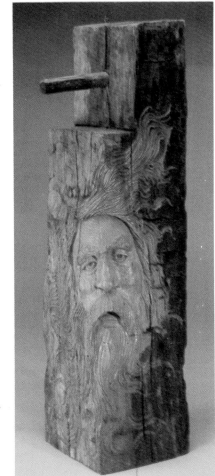

57

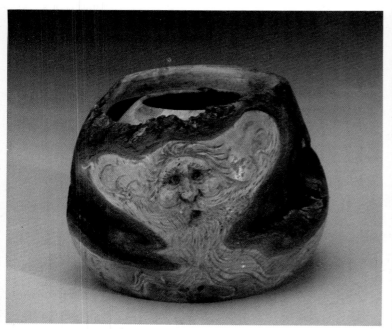

Small turned vase from oak burl.

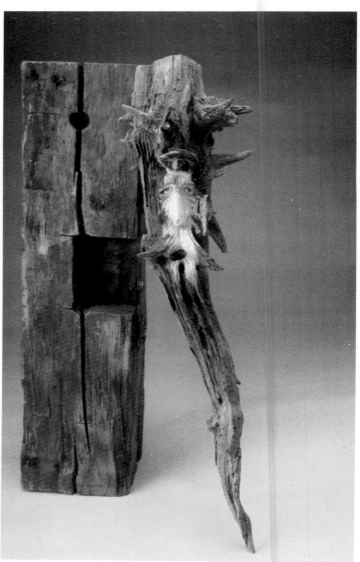

Tap root of a pine tree.

Cyprus knee comic figures.

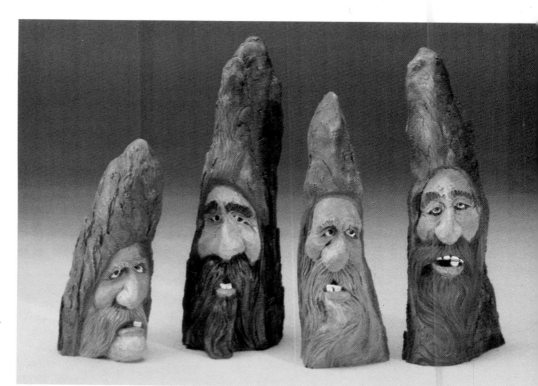

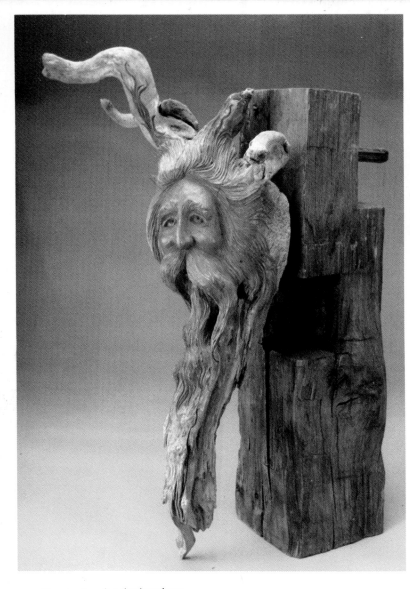

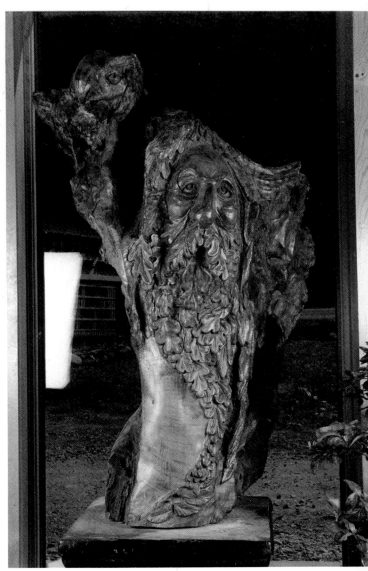

Root of a rhododendron.

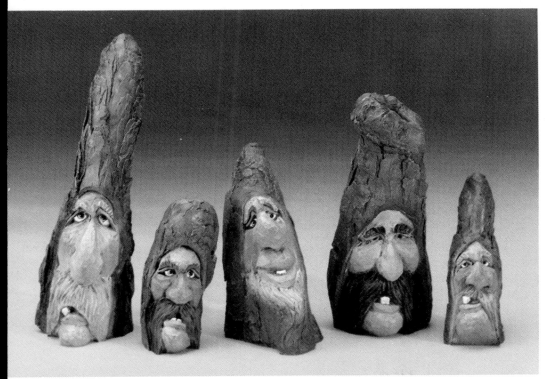

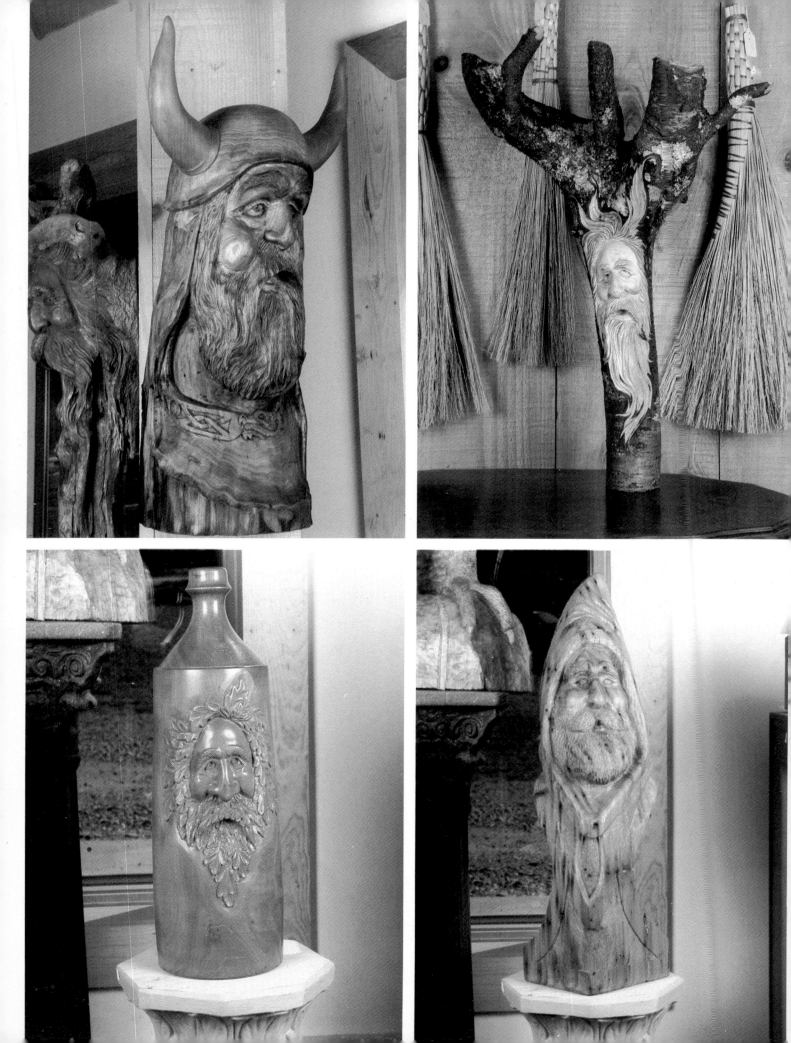

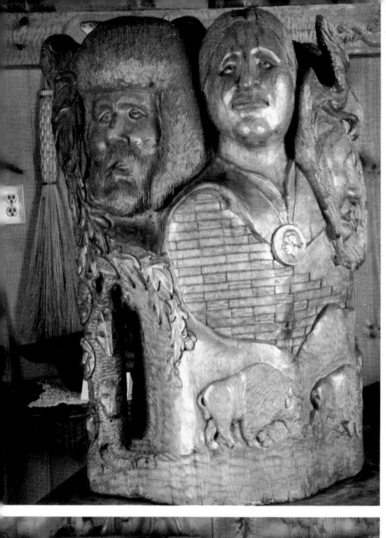

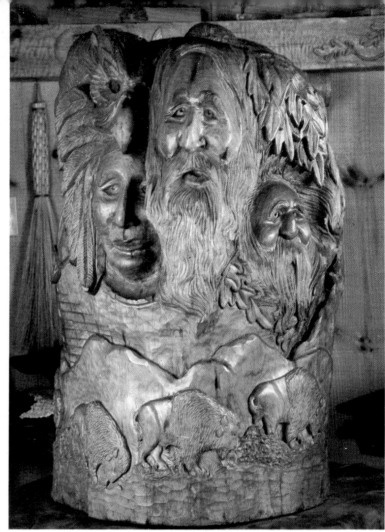

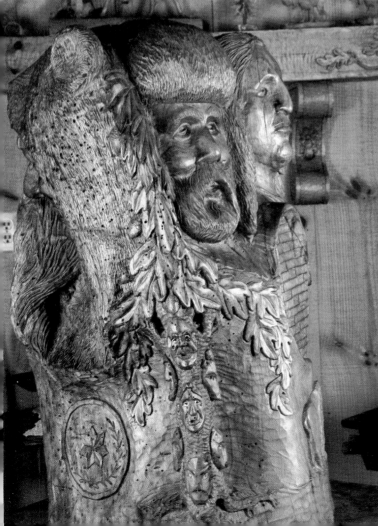

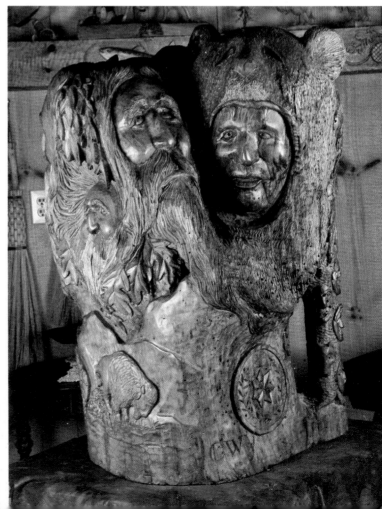

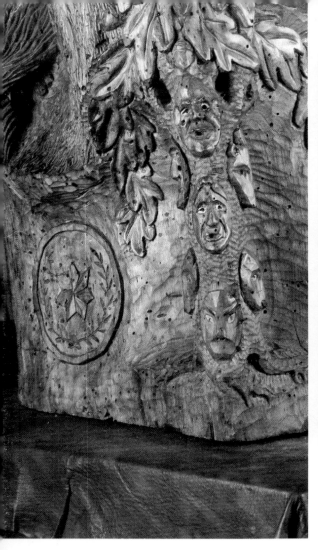

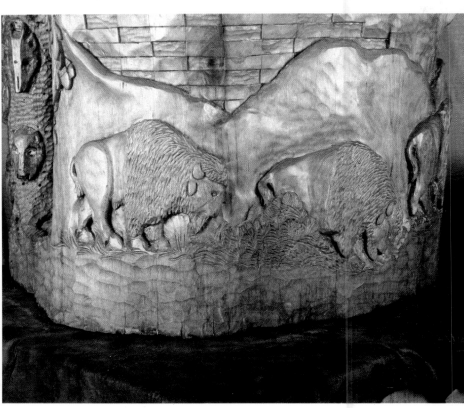

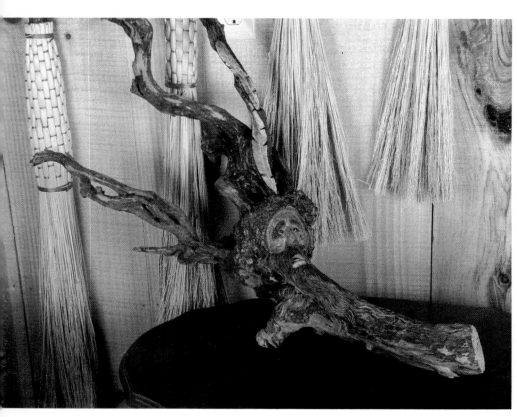

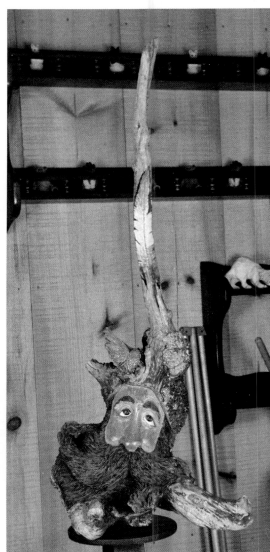

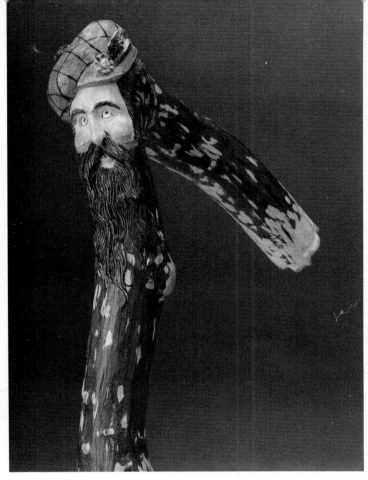

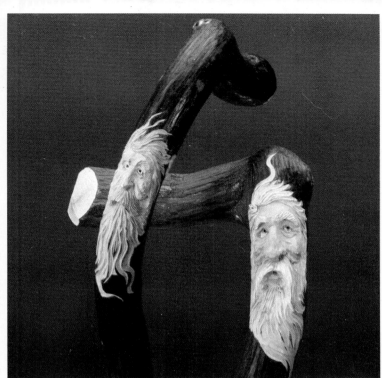

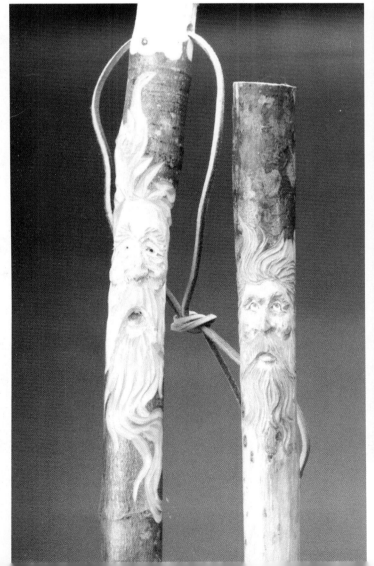

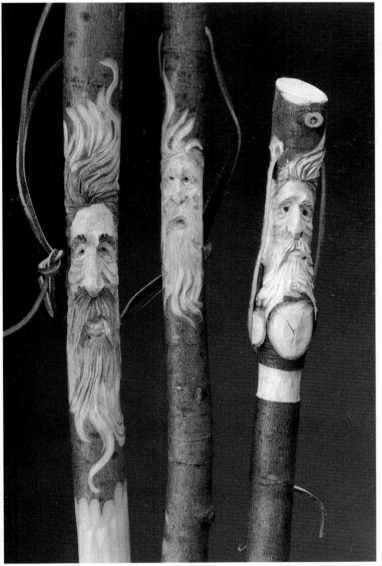

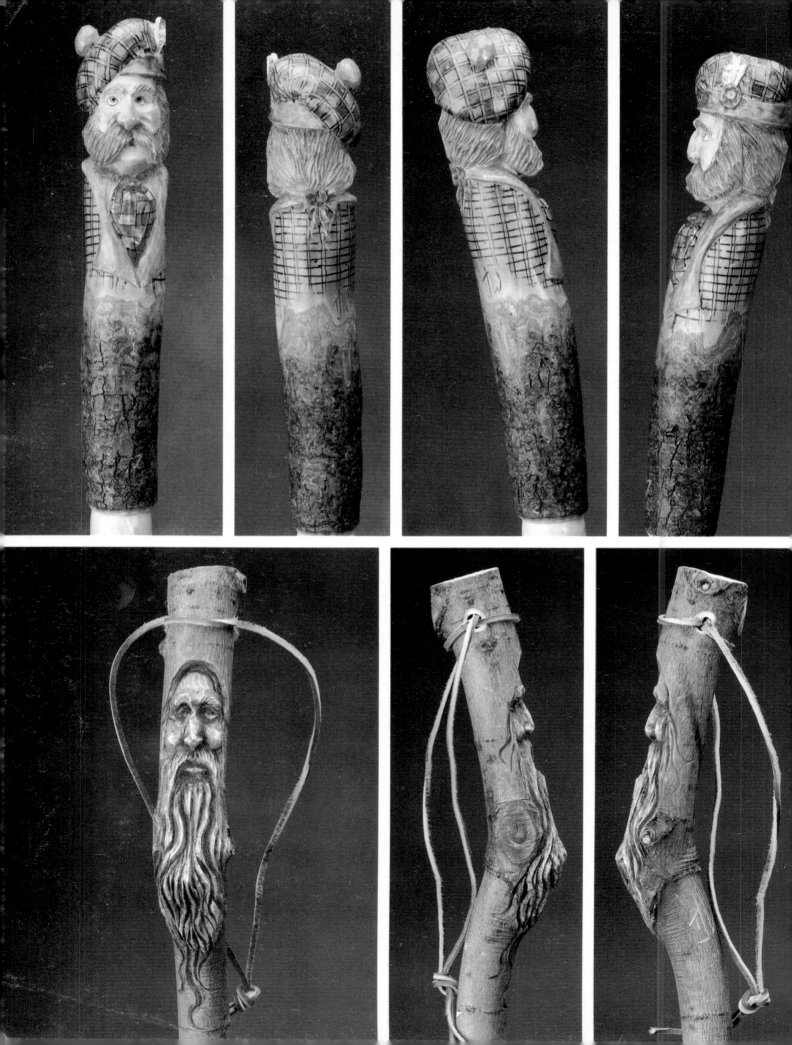